500

Digital Photography
Hints, Tips, and Techniques

A RotoVision Book
Published and distributed by RotoVision SA
Route Suisse 9, CH-1295 Mies
Switzerland

RotoVision SA, Sales & Editorial Office
Sheridan House, 114 Western Road
Hove BN3 1DD, UK

Tel: +44 (0)1273 72 72 68
Fax: +44 (0)1273 72 72 69
Email: sales@rotovision.com
Web: www.rotovision.com

10 9 8 7 6 5 4 3 2 1

ISBN: 2-940378-04-5
978-2-940378-04-3

Designed by Talking Design
Art Director: Luke Herriott

Reprographics in Singapore by ProVision Pte. Ltd.
Tel: +65 6334 7720
Fax: +65 6334 7721

Printed in Singapore by Star Standard Industries Pte. Ltd.

500
Digital Photography
Hints, Tips, and Techniques

The Easy, All-in-One Guide to those Inside
Secrets for Better Digital Photography

Chris Weston

Contents

Image Capture

Image Editing

Output

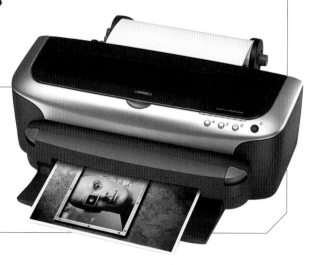

Author's preface

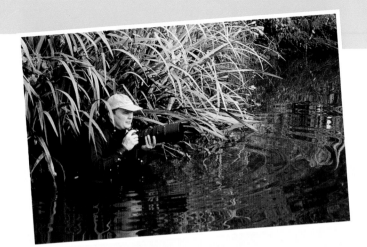

Until recently I was one of photography's traditionalists and a digi-skeptic. Then, I picked up a digital camera ... and have never looked back! Let no one tell you otherwise—we are party to a photographic revolution and these are exciting times. In much the same way that the invention of the Kodak Brownie box camera opened up photography to the masses, the advent of digital capture technology has been the genesis of a whole new generation of photo-enthusiasts. We are no longer reliant on a cocktail of chemicals to produce photographic images and our pictures can be viewed instantly, altered and enhanced at the click of a mouse, and whizzed around the world in a matter of seconds.

Rather than taking photography away from its roots, digital capture offers us far greater control over our images than we've ever had before. Photography has always been a two-part process: image capture and post-camera processing. Now, instead of relying on processing houses to do the processing, you have all the tools you need—quite literally—at your fingertips.

That's not to say that the art of photography is dead. It's just that, while others like to linger over the whys and wherefores of digital capture versus film, some of us have embraced this new technology for what it is—just another way of recording light. Because, although the digital revolution has been ... well, revolutionary, the practice of photography really hasn't changed at all. Great pictures still require that you understand the basic principles of photography—light, composition, design, creativity, and vision—and no amount of computer manipulation afterward will produce a compelling picture from just a poorly constructed array of pixels.

Great photographs don't just happen by magic, and over these pages I'm going to take you through 500 hints, tips, and techniques that will get you making pictures like a pro. From choosing the right equipment through to making prints good enough for your wall, if you want to learn to do it, this book will show you how. And, don't worry, I won't be baffling you with techno-speak and jargon, or blinding you with science. What you'll find is simple to understand, easy to implement, proven advice for quick results. This is a book that you can dip into as your knowledge grows and learn something new every time that you do. Long live the digital revolution.

Great photographs don't just happen by magic, and over these pages I'm going to take you through 500 hints, tips, and techniques that will get you making pictures like a pro.

Chris Weston
April 2004

Introduction

How does digital photography work? In principle, in much the same way as traditional film photography. Light passes through a lens onto a light-sensitive material, which absorbs and amplifies the light in order to make it visible. In the "old days" this material was a piece of film and it is replaced in digital photography by an electronic digital photo-sensor (DPS).

This sensor is an array of millions of light-sensitive cells, or photodiodes (PD), each responding to an amount of light falling on it when the camera's shutter is opened to expose it. A corresponding signal is then created, which in turn is digitized—given a number value—so that a computer can read it.

It's a little like painting by numbers. Imagine taking a piece of white paper divided into a grid of several million squares. Now, using the value of the electrical charge corresponding to each sensor on the array, color each square to match. If the charge was zero, no light reached the sensor and you could color the square black. If the value was high, a lot of light reached the sensor and you could leave the square white. Values in between can be assigned different shades of gray, and once you've completed the whole sheet you would have an accurate black and white picture of the original scene. In a nutshell, this is how digital photography works.

What about color? Usually, a red, green, or blue filter (corresponding to the primary colors of light) covers each cell, allowing that cell to respond to a single light frequency. The filters are arranged in a group of four: one pair of red and blue and one pair of green. This additional green filter is used because human eyesight is more sensitive to green light.

Once a number value has been assigned to each cell the cells are processed by the camera, which gives each pixel or picture element a color value calculated (or, in digi-speak, interpolated) from the data gathered from adjacent cells. This is a vital part of the process and is one of the main reasons why image quality is not solely determined by the size of the sensor or the number of pixels it produces. This explains why a $500 6 megapixel camera is not the same as a $1,000 6 megapixel camera and how two 3 megapixel cameras, for instance, aren't necessarily the same.

The image-making process

Apart from the type of material used to record the initial image, the major difference between film and digital capture is in what follows the image-capture phase of the process, described above.

In film photography, the role of the camera is now complete and the remainder of the process takes place outside the camera. With digital photography, however, the camera itself completes image processing and storage—the two additional elements of the process.

Image processing is achieved by collating the values of each pixel to form an image file. As well as taking the data collected in the image capture part of the process, the camera will also determine the structure of the file and may, depending on the type of camera, apply a series of quality control actions, such as improving sharpness, contrast, and color saturation. Again depending on the camera used, the image file may be compressed—a process that reduces the overall data size of the file, measured in kilobytes (kb) or megabytes (mb), to allow more images to be stored on the memory device.

Once the image has been processed it is written to memory, usually in the form of a memory card (see pages 26–27), which is inserted into the camera. Some cameras will, in the first instance, write the file to temporary memory (RAM) to speed the process and allow image capture to continue while the somewhat slower processes of image processing and storage are completed.

Photography, the digital way

Image capture
The lens projects an image onto the focal plane.

Color filter
The light passes through the colored filters and is analyzed as an analog signal.

Sensor
The light-sensitive sensors turn the image into pixels –a uniform pattern of microscopic squares, each containing brightness and color information.

Analog signal
The camera then sends an analog signal to the in-camera computer.

Image analysis
The final image is constructed by microchips and software and turned into a binary digital file.

Storage
The digital signal is sent to the storage device– usually a memory card inserted into the camera– where it is recorded as a digital file.

Types of color filter

There are two main types of color filter in use: the Bayer pattern mosaic filter and the Foveon® image sensor. The mosaic filter is the more common. A single filter (red, green, or blue) is centered over an individual sensor, with two green filters for each pair of blue and red in an array. Each filter passes light frequencies corresponding to its own color, but also some others: for example, a blue filter also passes some green. The Foveon® image sensor features three layers of photo-detectors embedded in silicon. This takes advantage of the fact that red, green, and blue light penetrate silicon at different depths, allowing all three colors to be measured at each pixel, to capture full color. With mosaic-type filters, each photo-sensor captures just one predominant color (red, green, or blue), relying on interpolation to assess, or "guess," the correct level of the other two. Depending on the software, this can lead to color artifacts and a loss of image detail. Thus, in principle, the Foveon® image sensor delivers better sharpness and color detail.

Digital photo-sensors
There are two main types of photo-sensor used in digital photography, CCD (charge-coupled device) and CMOS (complementary metal oxide semi-conductor). In principle they work in much the same way but they differ in the way they use the information they capture.

CCD
With a CCD-based sensor the data from each individual cell must be read off in turn, one by one. The whole area has to be scanned to retrieve the data and the reading must be completed before a further exposure is made. This interline process takes time and can limit how quickly pictures can be taken one after the other. CCDs also tend to be power hungry and sap your batteries faster than a CMOS device. And they suffer more from color artifacts, where, during processing, the sensor will "cover up" slight discrepancies in patterns, which can lead to a loss of image quality. On the positive side, they are far simpler and cheaper to manufacture than CMOS devices and market forces are pushing down prices. Additionally, they don't suffer from the same extraneous electronic noise that early CMOS sensors did, thus they give a cleaner image.

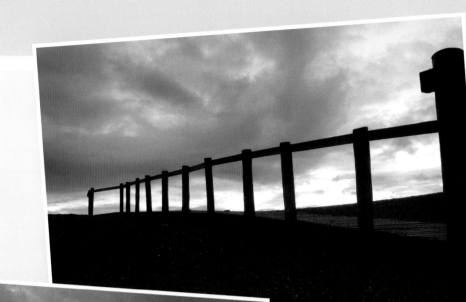

CMOS

From the manufacturer's perspective, CMOS devices are far more flexible than CCDs and can be put to many uses above and beyond simple image capture (exposure metering, for example). This added flexibility, however, does make them more expensive. From the user's point of view, the main advantage of a CMOS device is greater integrity in recording detail and, therefore, improved image quality—in theory. But early CMOS devices suffered from high levels of digital noise that reduced image quality—a main factor leading manufacturers to prefer to use CCDs. Newer CMOS devices, such as those used in Canon's high-end SLR cameras, have solved the issue. Also, because CMOS sensors run off a single low voltage, they don't eat their way through your batteries.

Full-frame transfer CCD

The year 2003 saw the launch of a digital camera with full-frame transfer capability. This system differs from the interline process described above and is managed by the pixels, rather than a separate channel. The main advantage is image quality. Because no transfer channel exists to take up space within the pixel, the light-receiving PD can be made physically larger, allowing more light (or electrical charge) to be received by that pixel. In turn, the larger electrical charge requires less amplification in producing the final image in the first instance, and in so doing increasing the signal-to-noise ratio (decreasing the level of noise) and enabling an overall increase in the dynamic range of the sensor.

Gallery 1: Life's a beach...

Digital photography's a great way to
capture a family day out.

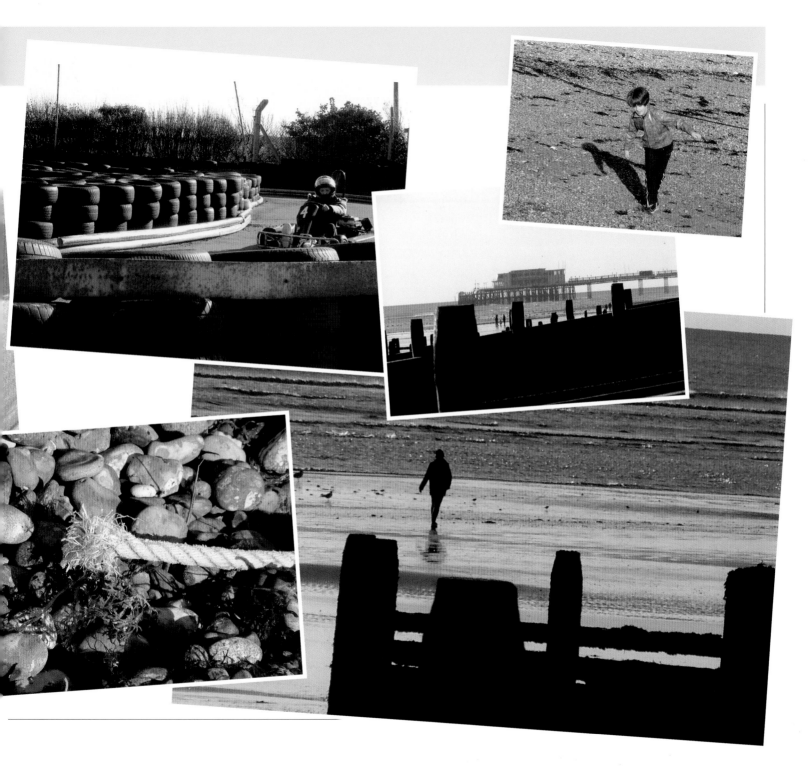

The 4/3 (four-thirds) standard

Many digital cameras, particularly SLRs, have been designed around existing 35mm camera formats and use lenses that were originally manufactured for film based photography. The problem with this approach is that film and DPSs record light in different ways. Film is sensitive to light falling on it from oblique angles and film-based cameras were designed to take account of this. The image sensors used in digital cameras are most effective when light hits the PD head on. Light striking from any other angle reduces image quality, seen on the final image as vignetting and poor color reproduction, particularly around the edge of the picture space.

The 4/3 format launched in 2003 aimed to optimize the performance of both image sensors and lenses. Under this format, the diameter of the lens mount is designed to be approximately twice as large as that of the image circle. Thanks to this, most of the light strikes the image from nearly head on, ensuring clear colors and sharp details even at the periphery of the image. To achieve the same for existing DPSs the lenses would be far too large and unwieldy, whereas lenses manufactured for the 4/3 system are smaller and lighter in comparison.

Why digital?

That, briefly, covers the hows of digital photography, but what about the whys? Here's a brief synopsis of the main advantages and disadvantages of shooting digital.

Advantages

• Better results, more often
Instant picture feedback allows you to make immediate adjustments to camera settings and composition, resulting in better quality results, more often.

• Cost
Digital cameras tend to be more expensive than film cameras, but think of all the money you would have spent on buying and processing film.

• Control
With the technology built into many digital cameras you have far greater control over the final image than you've ever had with film. No more relying on outside processors and printing houses.

• Image quality
A bit controversial, but, compared to like-for-like 35mm cameras, DPSs are superior at picking out detail, particularly in low-light conditions.

• Flexibility
The number of things you can do with your photographs once they're turned into digital code is amazing. TV shows, interactive Web sites, greetings cards, calendars, and fine art prints are all within range.

Disadvantages

• Speed
Only top-end professional cameras offer shooting speeds comparable with film cameras. If you like photographing action sports or wildlife, then you may be disappointed.

• Power consumption
Digital cameras eat batteries, so you need to make sure you have plenty of spares available on those not to be missed, once in a lifetime occasions.

• Dust
DPSs have a propensity for attracting particles of dust, which then appear on your pictures as gray blobs or bright spots. The sensor must be cleaned regularly, and this is not a simple task given the fragility of the device. Residual dust specks can be removed using cloning tools in photo-enhancement software (such as Photoshop), but this gets a bit annoying after a while.

• Lens magnification
The focal length of a 35mm lens is magnified by most digital cameras by around 1.5x. For wildlife or sports photography, this "extra" focal length can be a real boon, but if you like shooting wide-angle landscapes you may find your wide-angle lens isn't as "wide" as you thought.

The digital studio

For simplicity, the rest of this book has been set out to follow the general structure of the digital studio—image capture, image processing, and image output.

The first part takes you through the stages of, and the equipment used in, the making of photographs in-camera— the image capture part of the process. As well as providing advice on choosing equipment, it also takes you through specific shooting techniques for creating great pictures, such as exposure control, lighting, and how to achieve good composition.

The second part concentrates on how to perfect your images with the help of a computer and image-editing computer software, covering all the darkroom techniques now available at the click of a mouse.

The final part provides some interesting and exciting ideas for what to do with your photographs, including publishing them on the Web and printing them for display.

Hopefully, once you've worked your way through the 500 hints, tips, and techniques illustrated over the following pages, the process of creating fantastic digital photographs will no longer be a strange and confusing world of jargon and techno-gabble, but a clearly defined road map for creativity and fun.

Gallery 2: The world's your oyster

Once you're up and running you'll never want to be without your camera—every situation will be a photo opportunity...

Image Capture

EQUIPMENT

It's best to work out what equipment you really need and how to decipher the marketing spiel of the manufacturers and retailers so that you make the right decision. Here are top tips for choosing the best equipment for your needs.

Compact digital cameras

For general use, such as sharing photographs across the Web or for use in low-resolution newsletters, modern digital compact cameras produce excellent pictures with perfectly adequate image quality. Here is what you should look out for.

001 Pixel count

Choose a camera with adequate pixels for current and future needs. The number of pixels the DPS boasts is a key factor toward image quality and will dictate the size you can print to while maintaining quality. Use the table for a guide to the relationship between pixel count and print size:

Number of pixels (1 megapixel = 1 million pixels)	Workable print size
1 megapixel	6 x 4in (15 x 10cm)
2 megapixel	7 x 5in (18 x 13cm)
3 megapixel	10 x 8in (25 x 20cm)
4 megapixel	16 x 12in (40 x 30cm)
5 megapixel	20 x 16in (50 x 40cm)

002 Viewfinder

The viewfinder provides direct viewing of the subject but is offset from the lens, so that what you see through the finder isn't exactly what you get in the final image. Some more sophisticated cameras have an electronic viewfinder (EVF) that overcomes this problem, showing the whole image. They tend also to be brighter, making them easier to use in low light and night conditions.

004 Shutter release

In most cameras, the shutter release has two stages. Pressing it halfway activates any AF (auto-focus) and AE (auto-exposure) functions, which will remain locked so long as the button remains depressed. Pressing the shutter release all the way will then activate the shutter and take the picture.

003 Viewfinder or LCD?

Because many digital cameras show the through-the-lens image directly on the LCD (liquid crystal display) panel there is in theory no need for a viewfinder. However, the LCD necessitates holding the camera away from the body for effective viewing. Using a viewfinder makes the camera more stable as it is held close to the body. A viewfinder is also useful in bright conditions, when it is often difficult to see the image on the LCD.

005 Shutter lag

Some digital cameras have a delay of up to two seconds between pressing the shutter and the shutter actually operating, generally caused by AF and AE operation. This can make spontaneous photography of moving subjects, such as children, animals, and sport, almost impossible.

LENS OPTIONS

006 Lens type

The quality of the lens optics is probably the most important factor determining image quality. Compact cameras come with varying lens options, from fixed focal length to high magnification zooms.

007 AF lenses

The very best compact lenses have true auto-focus functionality (not simply a wide angle and small maximum aperture, which gives such vast depth-of-field as to appear to have auto-focus).

008 Zoom lenses vs. prime lenses

Fixed focal length lenses (sometimes referred to as prime lenses) generally give better optical quality than a zoom lens, but a zoom lens provides more flexibility.

009 Zoom control

If your camera has a zoom lens, then the zoom control allows you to alter the focal length (magnification factor) of the lens, usually from wide angle (for subjects such as landscapes) to telephoto (essential for wildlife or sport).

010 Magnification factor

Choose a camera with a lens that allows you to photograph best the subjects you're interested in. For general photography, a zoom lens with a magnification of 3x is ideal, while for wildlife and sports, where your subject is usually in the distance, you may prefer a greater magnification–even up to 10x.

011 Optical zoom vs. digital zoom

If you want a camera with a zoom lens, go for one with an optical (as opposed to a digital) zoom. A digital zoom works by cropping and then digitally enlarging the central area of the frame, giving the effect of zooming in, but the process significantly decreases image quality so should be used as a last resort.

FLASH TIPS

012 Flash

Some cameras offer a choice of flash modes that may include
- red-eye reduction (see tip 014, below)
- flash-on, which provides fill-light on brighter days
- flash-off, for use when flash is prohibited (for example, at some religious festivals, in museums, and at zoos).

013 In-camera flash

The most important aspect to flash is the guide number–a measurement of the power of the flash unit. The more powerful the flash (shown by a higher guide number), the further the light travels. If you want to photograph subjects from a distance, such as in a large sports arena, then choose a camera with a more powerful flash unit.

014 Red-eye reduction facility

If you take a lot of photographs of people or animals, then make sure the camera you choose has a red-eye reduction facility, which will help avoid those gruesome, demon eyes.

LCD

015 LCD panel

The liquid crystal display panel (LCD) enables you to review your photographs instantly. This allows you to spot any poor picture elements and re-shoot, before saving to memory.

016 LCD magnification

Options to magnify the image in the LCD are useful, allowing you to check tiny areas of the photograph for sharpness and good composition (for example, making sure your subject didn't blink as the picture was taken).

017 Memory card holder

Don't buy a camera that uses little known storage media: go for one that is tried and tested and readily available. This will give you the comfort of knowing that all your precious photographs are safe.

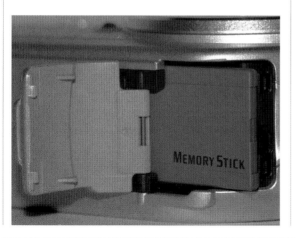

018 Exposure modes

If you wish to retain some control over exposure, or if you expect your photography to develop beyond simple point-and-shoot, then look for a camera that offers some form of manual exposure override. This may be (at the very least) an exposure compensation function, or (preferably) aperture-priority and/or shutter-priority AE, or full manual exposure.

Digital single lens reflex (SLR) cameras

For even better image quality and greater photodiversity, the digital SLR is the ideal camera for anyone taking their photography seriously. Still lightweight, its larger size gives more room for processing power and interchangeable lenses–and a whole range of bolt-on accessories is available.

019 Shutter release

Unlike digital compact cameras, DSLRs do not suffer time lag between pressing the shutter and the shutter activating, making response times much quicker and suited to all styles of photography.

020 Mode selector dial

Most of the camera's functions are also available through the menu options on the LCD panel, but they are easier to operate via a mode selector dial.

021 Lens mount

Most DSLRs have a proprietary lens mount. When choosing a camera body, be sure to check the extent of the backup lens system, making certain it will support your photographic interests both now and in the future. (For more about lenses, see pages 23–25.)

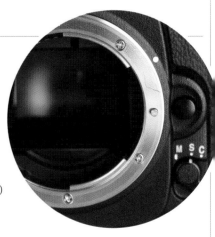

022 Depth-of-field preview

Managing lens aperture to get just the right amount of sharpness in your pictures is one of the fundamental elements of photographic technique. This little button makes life much simpler by allowing you to see exactly the available depth-of-field.

023 Reflex mirror

When you take a photograph, the reflex mirror flips out of the way of the shutter curtain, allowing light to pass through to the DPS to make the picture. This action causes a small amount of vibration and, in extreme circumstances, particularly at slower shutter speeds, can cause your images to blur–even with the camera mounted on a tripod. To overcome this, some cameras have a mirror lock-up facility–a must have if you often photograph landscapes.

024 AF focus mode

If you enjoy photographing moving subjects, such as sporting events, wildlife, and candid portraiture, then it's worth investing in a camera that has an AF tracking function, which maintains focus on a moving subject.

025 Prism finder

Not all cameras have a prism finder with 100 percent coverage. If not, then you need to allow for these unseen areas of the photograph when defining your composition, realizing that what will end up on the DPS is more than you see through the viewfinder. Generally, only top-end DSLRs show 100 percent, so it's worth checking what the coverage of your preferred camera is and running some test shots for future reference.

026 Focus points

Murphy's law has it that your subject is never in the same area of the picture space as your focus detector(s). The more focus points the camera has, the more likely you are not to fall foul of one of AF's main limitations.

027 Rear LCD panel

These are generally bigger on DSLRs than on compact cameras, which make them better for previewing your images, but they are just as prone to glare under bright lights. A brightness level adjustment function is a useful feature to help get the best from your preview screen.

028 Viewfinder

Check the viewfinder for brightness—if it's too dark, composition can be difficult, particularly in low light conditions.

029 Remote shutter release

A remote shutter release, either cable or electronic, is useful for avoiding camera vibration and blurred images when using the camera mounted on a tripod.

030 Accessory shoe

If you plan to use on-camera flash and certain remote trigger devices, then your camera will need an accessory shoe.

031 Burst rate

For fast moving action, you need a camera with a high burst rate. There are two things to look out for: the frames per second (fps) speed and the continuous shooting rate (csr), which refers to the number of images that can be taken before the shutter locks.

032 ISO equivalency rating (ISOE)

The lower the ISOE rating (e.g. 100) the more light it takes for an image to form, compared with a high rating (e.g. ISOE 800). The greater the range of the ISOE settings on the camera, the more control you will have over exposure and composition. Ideally, the camera should have ISOE 100 to ISOE 800 settings as a minimum.

034 Auto WB

Most cameras also come with an auto WB (white balance) function, where the camera detects the color temperature and automatically sets the appropriate WB setting. This is a useful feature but not necessarily one that is to be relied upon.

035 Noise reduction

Some cameras come with a noise reduction function. This can be very useful when using very slow shutter speeds, when the problem of digital grain or noise is greatest.

036 Image quality

In digital photography, images can be saved in a number of different formats. Typically, these include RAW, TIFF, and JPEG files. Some cameras also allow you to store both RAW and JPEG files simultaneously. For high quality images, either RAW or TIFF settings are best. For downloading images directly over the Internet, JPEG images have smaller file sizes, due to increased compression. RAW images usually need to be opened in proprietary software before further processing can take place, but alterations can be made post-camera as if they had been made in-camera at the time of shooting.

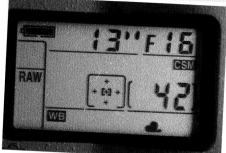

033 White balance (WB)

To overcome color shifts caused by the color temperature of different light sources and the time of day, you need to use the WB setting. Practice shots will show the effects of different settings.

Conditions	Setting
Sunrise/sunset	Cloudy
Midday	Normal daylight (or Cloudy for a warmer image)
Overcast conditions	Cloudy
Heavy shade	Shade
Household lightbulb	Incandescent
Fluorescent tube	Fluorescent
Camera flash	Flash

037 Build quality

Most of the more affordable cameras are manufactured in molded plastics, suitable for general use but unable to withstand too many hard knocks or continuous heavy use. More expensive cameras often have a metal chassis that helps to protect the precision engineering within. This is worth the additional cost if you're going to give your camera hard use.

Interchangeable lenses

A DPS will only record what it sees through the camera's lens, and no amount of post-camera manipulation with a computer will be able to generate detail that never existed in the first instance. The lens, more than any other single factor, affects the quality of your final image.

Equivalent focal length

The 50mm lens on a 35mm film camera is referred to as "normal" because its angle-of-view is close to that of the human eye. With most digital cameras, the focal length of the lens is magnified because the DPS has a smaller area than that of 35mm film.* Effectively, this smaller surface area alters the focal length of a 35mm lens by narrowing the angle-of-view, as shown in the table below.

*Some Canon cameras have a full-frame CCD, meaning that it has the same surface area as 35mm film and, as such, focal length is unaffected.

The effect of the magnification factor (MF)

Focal length for 35mm camera	with 1.5x MF	with 1.7x MF	with 2x MF
17mm	26mm	29mm	34mm
20mm	30mm	34mm	40mm
24mm	36mm	41mm	48mm
28mm	42mm	48mm	56mm
35mm	52mm	60mm	70mm
50mm	75mm	85mm	100mm
60mm	90mm	102mm	120mm
80mm	120mm	136mm	160mm
100mm	150mm	170mm	200mm
135mm	200mm	230mm	270mm
200mm	300mm	340mm	400mm
280mm	420mm	475mm	560mm
300mm	450mm	510mm	600mm
400mm	600mm	680mm	800mm
500mm	750mm	850mm	1000mm
600mm	900mm	1020mm	1200mm
800mm	1200mm	1360mm	1600mm

Some figures have been rounded up or down to their nearest practical equivalent.

Choosing lenses for digital cameras

The choice of lenses is vast and different lenses are selected for a variety of compositional reasons (as described later in this section). Growing numbers of digital-specific lenses are now becoming available, increasing the options still further. The difference between a digital lens and a non-digital lens lies in telecentric design. Because of its physical depth, for each photodiode on the DPS to receive the maximum possible charge, light has to fall on it from as close to 90° as possible. If the angle is too great, then much of the information for that area of the scene is lost, causing vignetting, discoloration, and noise, most often seen at the edges of the frame. A telecentric lens allows light to hit the sensor at very close to a right angle, optimizing image quality. The following tips should all be helpful when you are deciding which lens is best for you.

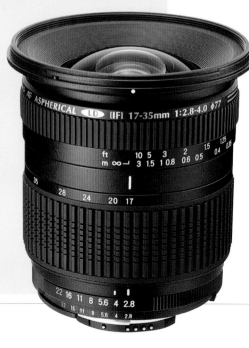

038 Cost

Always buy the most expensive lenses you can afford. Choose a less expensive camera body and a quality lens rather than vice versa. It is the lens that passes the information (i.e. light) through to the DPS, which then records it. If the information isn't there to start with, you'll never recreate it on a computer.

039 Prime lenses

Prime lenses (lenses of a fixed focal length) are generally of better optical quality, due mainly to the reduction in the amount of glass that light has to pass through. For very wide-angle lenses and super telephoto lenses, prime lenses give noticeably better image quality.

040 Zoom lenses

Zoom lenses provide the greatest flexibility in composition, allowing you to alter the focal length exactly as needed. Avoid extreme zooms (with a very wide range, such as 70–500mm or 28–300mm), as their quality is compromised by their versatility.

041 Telecentric design lenses

For most digital cameras, digital-specific, telecentric lenses–such as those made by Nikon, Tamron, and Olympus–improve image quality. The main disadvantage is the lack of choice in focal lengths currently available, but expect to see more models appearing in the near future.

042 Independents vs. own-brand lenses

While there are exceptions to the rule, the best own-brand lenses (such as Nikon and Canon) are better quality than the best independents (e.g. Tamron, Tokina, and Sigma). However, it is worth checking some of the test reports published in the major consumer photo-mags for specific like-for-like comparisons.

043 Magnification factor (MF)

MFs have positive and negative implications, depending on your photographic interests. Landscape photographers, for example, who often shoot with a wide-angle lens, lose some of the effects because the angle-of-view is decreased by the increase in focal length. Wildlife photographers, on the other hand, leap for joy as the increase in focal length helps them to get frame-filling images of distant animal subjects.

044 IS and VR lenses

Image stabilizing and vibration reduction lenses utilize internal sensors that detect camera shake and motors that automatically adjust the lens elements to minimize blur. This technology reduces camera shake, and allows handholding of the camera at shutter speeds slower than with a conventional lens. The two systems, developed by Canon and Nikon respectively, are a real bonus when handholding the camera is the only option and pin-sharp images are essential. Sigma now also make an optical stabilized lens.

045 Auto-focus

If speed of focusing is important to you, then always test AF performance before you buy any AF lens–some systems are much slower than others.

046 Internal focusing (IF)

IF lenses are more compact and lightweight in construction than lenses where the barrel extends outward when focusing.

047 Low dispersion glass

Lenses that use low dispersion glass help to minimize chromatic aberration, a type of image and color dispersion that occurs when light rays of varying length pass through optical glass. In so doing, they improve sharpness and color correction in the final image.

048 Aspherical lens elements (ALE)

Lenses with ALEs produce better image quality by eliminating the problem of coma and other types of aberration that are particularly prevalent in wide-angle lenses used in conjunction with wide apertures.

049 Maximum lens aperture

The maximum aperture of the lens will, to some extent, dictate the level of control you have over exposure settings. For example, in low light conditions with a slow lens (e.g. a lens with a maximum aperture of f/5.6 or less) you may not be able to attain the shutter speed necessary to freeze motion or capture a sharp image. However, with long-telephoto lenses, a wide maximum aperture dictates a very large and heavy lens, which can be difficult to carry and support. When selecting a lens, try to determine beforehand the conditions you are most likely to be photographing in and balance maximum aperture with portability.

050 Maximum aperture and zoom lenses

With some zoom lenses, the maximum aperture can vary depending on the focal length set. This system is used to reduce the size and weight of the lens but, again, can limit your options when it comes to setting exposure. If possible, always opt for a zoom lens with a fixed maximum aperture.

051 Determining perspective

A lens with an equivalent focal length of 50mm will give you an image that is close to that perceived by the human eye. Wide-angle lenses will increase the amount of the scene visible in the picture space and make objects within the scene appear further apart. Telephoto lenses, on the other hand, will include less of the scene and make the objects appear to be bigger and closer together.

052 Macro lenses

These are used when you want to get very close to the subject, often within inches, and when you want to create lifesize or bigger magnification. They come in varying focal lengths—usually from 50mm to 200mm—as well as a zoom range. Image quality is generally superb, with very minimal levels of distortion.

053 Lens hoods

Lens flare is caused by stray light from the sun, or other bright source, falling directly onto the front of the lens and then bouncing around the inside of the lens barrel. It shows as polygonal shapes on your pictures, which do nothing for composition and artistic merit. Attaching a lens hood to the front of the lens helps to soak up any stray light and minimizes the effect. It is advisable always to use the lens manufacturer's recommended model, particularly with wide-angle lenses, to avoid vignetting, which can occur if the hood is too large and cuts into the angle-of-view of the lens.

Useful gadgets and accessories

Camera stores offer a multitude of different gadgets that you can add to your camera system. Some will be of little use to you in reality, while others will greatly add to your ability to take good pictures.

MEMORY CARDS
Just as you get different types of film (35mm, APS, 120 and 220 roll film, and 5x4 sheet film, for example), so you can buy different types of memory card. This section of the book aims to narrow down the choice a bit.

054 Compact flash (CF)

The CF card is the most popular form of storage media on the market today. The cards come in a variety of capacities, from 16mb up to 4gb.

057 Multimedia cards (MMC)

These are designed to interface with an array of digital devices, from cameras to mobile phones, that have either an MMC slot or a secure digital (SD)slot.

058 Memory stick (MS)

Sony's MSs are widely used on their digital cameras and video recorders. Compatibility with other makes is poor but reliability and capacity are good (16mb-1gb). An erasure-protection lock prevents overwriting or deletion of files.

060 Compatibility

Choose a memory card that is compatible with all your current digital devices (camera, card reader, computer, etc.).

055 Smart media (SM)

SM is extremely lightweight and wafer-thin, though this makes it quite fragile for use in the field. The maximum capacity (up to 128mb) of the card is limited by the camera's circuitry.

059 Secure Digital (SD) cards

These are ultra lightweight and wafer thin, though this makes them quite fragile for use in the field. The card's maximum capacity (up to 128mb) is limited by the camera's circuitry.

Approximate number of images per capacity

DPS size (Megapixels)	File size	32mb	64mb	128mb	256mb	512mb	1gb	2gb	4gb
2	0.9mb	35	71	142	284	568	1137	2275	4551
3	1.2mb	26	53	106	213	426	853	1706	3413
4	2.0mb	16	32	64	128	256	512	1024	2048
5	2.5mb	12	25	51	102	204	409	819	1638
6	3.2mb	10	20	40	80	160	320	640	1280

056 Microdrive (MD)

IBM's MD is, in effect, a miniature hard disk drive. MDs are used in professional systems because of their robust, high-speed, high-capacity (170mb–1gb) features.

061 Write speed

MCs differ in their comparative write speeds–the rate at which they read data from the camera. The faster the write speed, the quicker the data is downloaded and the sooner you can take the next picture. This is important for fast-moving subjects such as wildlife or motor sport.

Using memory cards

Memory cards are inserted into the camera body so that images captured by the DPS can be saved onto them. Before using the card you may need to format it, which is done using the menu option on the camera. Once in use, you can remove the card at any stage, either to change it for a different card or to transfer the written files to a computer (using a card reader, for example) or to another storage device (such as a portable hard disk drive). You can also erase images you don't like as you go along, making room for more pictures. The only time you shouldn't remove the card from a device is when it is being accessed. Always refer to the indicator lights, which tell you it is safe to remove the card.

062 Size

You can now buy MCs with a capacity of up to 4gb, which is the equivalent of around 4500 high-resolution JPEG images. But what if your card fails when it's almost full? That's a lot of pictures to lose. It's best to use a smaller size card and download to a permanent storage device more often.

063 Reliability

Not all memory cards are alike and some are of better quality than others. Until you transfer your pictures from the MC to a permanent storage device, if your MC goes wrong you'll have lost your images for good. Reliability costs money, but it's always money well spent.

MOBILE STORAGE DEVICES

Out in the field it is useful to be able to transfer your files from the memory card to a more permanent form of storage. This frees up space on the memory card to let you take more pictures; it protects photographs from accidental loss or damage, and it provides a permanent backup. Carrying a laptop may not be practical but there are two main types of alternative portable storage device: the hard disk drive (HDD) and the CD writer.

064 Portable HDD

Portable HDDs (hard disk drives) provide pocket-sized storage of up to some 20gb of data, which means hundreds or thousands of digital pictures. They generally have a screen for previewing images and the stored files can be transferred to a computer or printer.

065 Portable CD writers

These work by writing the information from the memory card to the CD-R or CD-RW disk, which means you need to carry some spare disks with you. There is no facility for viewing the images, which must be transferred to a PC or MAC for viewing.

066 Reliabilty

The single most vulnerable part of any computer is the hard disk drive (HDD). This is because it is the only mechanical component. HDDs don't like being moved and jolted around, which can lead to faults occurring. A CD, on the other hand, once written, is relatively immune to damage and so provides a more stable medium for portable storage.

067 Backup Files

The other advantage of the CD over the HDD is backup. Once the CD is written, it can be retained as a permanent backup to your computer storage in case your computer should fail at any time.

068 Card compatibility

When choosing a portable storage device make sure that it accepts the memory card type you are using.

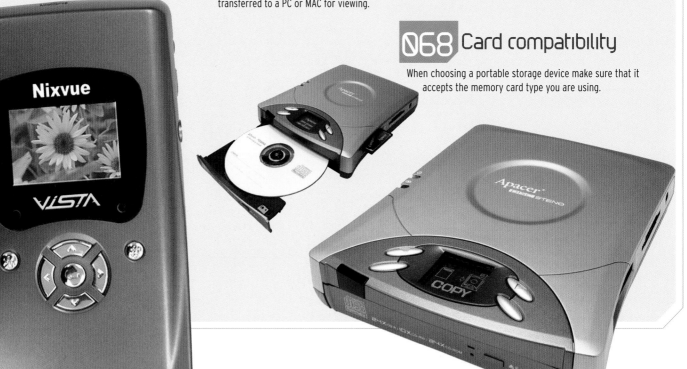

Carrying your equipment

You will soon have built up a good deal of equipment to carry when you are out and about. There are numerous options for carrying equipment in the field and often what's right is what you find most comfortable.

069 Hard cases

A hard case is ideal for carrying equipment safely on an airplane. Watertight and airtight, hard cases withstand the roughest treatment from airline baggage handlers. They are, however, very heavy and often quite cumbersome, though the better ones have wheels to make them more portable.

070 Backpacks

These are similar to the type of pack you would use for outdoor activities, except that the inside of the pack has dividers to store and protect your equipment. Backpacks are ideal for the adventurous outdoor photographer who carries large amounts of equipment for relatively long periods. They vary in price, but you should expect to pay a lot for a good one.

071 Pouches

If you just want to carry a single camera with you then a belt pouch is a simple, comfortable means of keeping your camera safe and accessible.

072 Rucksacks

With no inner structure, rucksacks have separate pockets for different equipment. They are useful for carrying small amounts of equipment on a hike, but finding the right bit at the right time can be hard.

073 Handbags

If you're carrying a relatively small amount of equipment and not travelling far, a handbag may be the best choice. These come in various sizes and will carry a complete SLR system, including a selection of lenses. Side pockets offer useful additional storage space for small accessories such as remote shutter release and small flash units.

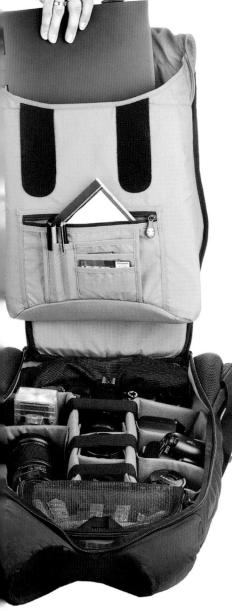

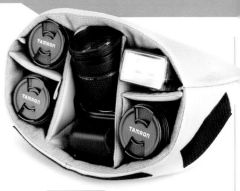

074 Travel systems

Companies such as Lowepro produce travel systems for camera gear, with integrated, attachable bag accessories that fit onto a main backpack. Additional bags for specific lenses and other gear can be bought separately to be added on or removed as required. This is a highly flexible system that is adaptable to your changing circumstances and needs, but you have to pay for the privilege.

075 Size

Make sure the bag or case has enough room to carry all the equipment you might need at any one time, plus some room for any new equipment you may end up buying at a later date.

076 Weight

Make sure the bag is light enough when full for you to carry it for long periods, if, for example you are interested in landscape or wildlife photography.

077 Carrying tripods

If you regularly use a tripod, choose a bag that offers a built-in tripod carrier. This will make your life much easier on those daylong treks and hikes through the countryside.

078 Padding

As well as being convenient, a camera bag should offer adequate protection for your expensive and delicate equipment. Make sure that the bag you choose has good, firm padding that will absorb any bumps and knocks.

079 Accessibility

Make sure your equipment is easy to locate and access from the bag. There's nothing worse than rummaging around in a disorganized pack while some extraordinary event occurs in front of you.

080 Airlines

Give airline staff your every assistance. If possible, carry your delicate gear (cameras, lenses, laptop, etc.) as cabin baggage. If you have too much equipment, use a photo-specific hard case, and check it in as hold baggage.

081 Security

If you check in a camera bag with the airline, place it in an old duffel bag, or disguise it in some other way. A camera bag that looks like what it is is an obvious target for airport thieves.

082 Weather proofing

For outdoor use, get a photo-bag that offers weather protection. Many backpack type camera bags have a rain resistant cover that can be easily pulled over the case, and fully waterproof bags are also available.

083 Comfort

If you opt for a backpack, try it before you buy. Having the adjustable straps fitted specifically for you can make a huge difference. Get the store assistant to help and remember it will weigh more when full.

Camera supports

Keeping your camera steady—and your photographs free of camera shake—is vital. When the light is low, with heavy equipment, such as a long telephoto lens, or whenever pin sharp images are critical, you'll need to use a camera support. Usually, this means a tripod.

084 Tripods

Tripods are the ideal solution to blur-free images. They can be a bit bulky and heavy to carry but they're worth their weight in gold to the serious photographer.

085 Rigidity

Go for the biggest, heaviest tripod you can carry and can afford to buy. The stronger the tripod, the more stable the camera and the better your pictures will be, particularly when you are photographing at slow shutter speeds.

086 Flexibility

For some areas of photography, particularly close-up work, it's useful to have a tripod that has full flexibility of movement, allowing you to get close to the ground and into contorted angles.

087 Carbon fiber

To cut down on weight without compromising rigidity, opt for a carbon fiber tripod. Typically, these are one third lighter than traditional metal tripods, although you can expect to pay more than a third more for them.

088 Tripod heads

The tripod head is just as important as the legs. Make sure the model you choose can take the full weight of your camera with your heaviest lens attached, otherwise you'll defeat the object of using the tripod in the first place.

089 Quick release

For speed of operation, choose a tripod head with a quick release mechanism and always keep a quick release plate attached to your camera bodies, lenses and other frequently used equipment.This will save you missing great shots as you unscrew the camera from the bracket.

090 Tripod head type

I use a pan and tilt tripod head for static subjects such as landscapes. For faster, more flexible movement (e.g. in wildlife photography), I switch to using a ball and socket type head.

091 Monopods

A monopod is one solution to the weight and bulk problem of tripods. However, monopods don't offer the same level of sturdiness that a tripod provides.

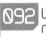

Flash units

Light is required for an image to be recorded. Unfortunately, there sometimes just isn't enough of it. Whether in a dimly lit room or in the low light of dusk or pre-dawn, it's sometimes necessary to add in a little extra light.

092 When to choose a monopod

Always opt for a tripod if circumstances permit, as they are more stable than monopods. However, monopods can be useful in confined spaces and can be faster to use for some types of photography, such as sport and wildlife.

095 Built-in flash

Many cameras have a built-in flash either above or just to the side of the lens. These small flash units are of limited use because of low power and slow recycling times and their position close to the lens gives the least dynamic lighting. However, they can be useful for bursts of fill-flash.

096 On-camera flash

More sophisticated cameras have an accessory shoe that sits on top of the viewfinder prism, which can be used to hold a dedicated auto-flash unit. These units are more powerful than the built-in variety but suffer the same limitations of flat, frontal lighting. Some units are designed to overcome this problem by letting you angle and/or rotate the flash head for bounce flash, which is much softer in quality than direct, head-on flash.

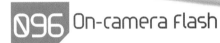

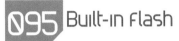

093 Beanbags

In confined spaces, and with big, heavy lenses, a beanbag can be better than a tripod. Beanbags are inexpensive, provide freedom of movement, and cushion the impact of vibration.

097 Off-camera flash

A better solution is to position the flash unit slightly off-camera, on a flash bracket that attaches to the tripod mount on the base of the camera. Off-camera flash has the advantage of both power and direction, giving much more dynamic lighting. On the downside, these units can be quite awkward to carry.

094 Beanbag fillings

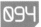

Natural fillings, such as maize, rice, or, well, beans, are better than synthetic materials such as polystyrene, which tend to soften and flatten out over time. (Keep maize-filled bags away from elephants, as they take quite a liking to them.)

098 Ring (macro) flash

A special type of flash unit is the ring flash, or macro flash, as it is sometimes referred to because it is used extensively in close-up (macro) photography. This unit fits around the lens barrel and gives shadow-free lighting that can be used to good effect for portraiture as well as macro work. These flashes are quite costly, however, and are limited to specialist use.

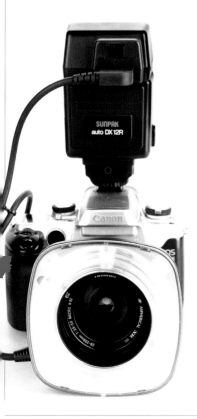

What to look for in a flash

099 Power output

In general, the more powerful the flash unit, the greater the control you have over exposure settings and composition. The power is measured by Guide Number (GN): the higher the Guide Number, the more powerful the flash.

102 Comparing like for like

When comparing the GN of two or more flash units check that they have been calculated from the same parameters. For example, a flash unit with a GN of 120 for ISO 1600 equivalency is less powerful than a flash unit with a GN of 40 for ISO 100 equivalency. This is a common technique used in sales to make the less powerful flash units appear to be more powerful than they actually are.

103 Flash/camera communication

Manually calculating flash output and exposure can be tedious and takes time. If you want your camera and flash to cope with this, opt for a dedicated flash unit that will "talk" with your camera to make all the necessary exposure decisions, leaving you time for composition and framing.

100 Coverage

Most flash units are designed to cover an area roughly equivalent to that of the human eye, or a 50mm equivalent "standard" lens, (around 75mm in digital terms). If you are using a lens with a narrower or wider angle-of-view, then the standard flash coverage will either give, respectively, too much or too little light. The best flash units have a zoom function that lets you set the flash coverage to match your lens.

104 Recycling time

If you photograph fast moving subjects with flash (children, for example), then you will want a flash unit that works in continuous bursts to match your camera. Check what the recycling time of your preferred flash unit is, to make sure it meets your needs.

101 Flash exposure compensation

Too much power from the flash unit can kill your photographs, for example, when photographing very close to your subject or when using flash for fill-in lighting. Look for a flash unit that lets you reduce the power output for individual shots.

105 Red-eye reduction

If your camera has a built-in flash unit, check to see whether it also has a red-eye reduction facility and set this to "on" when photographing people or animals. It will help avoid those devil-like eyes caused by light reflecting off the retina.

TECHNIQUE

All the equipment in the world won't help you take great pictures without good photographic technique. Here, we demystify some of the secrets of photography and give a guide to simple techniques for using light, composing the picture, and sound fieldcraft.

Using light

Photographers talk about "good" lighting and waiting for the "right" light. But what exactly is meant by these terms? Learning how to use light well can be tricky. Here are top tips for great photographic lighting.

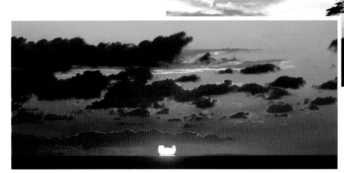

The color of light can vary from red/orange to blue, depending on the weather and the time of day.

106 Color of light

Depending on the time of day, weather conditions, and whether it comes from a natural or artificial source, the color of light changes. The human eye may not notice these changes, but cameras do.

107 Color temperature

We think of light as being either cool (i.e. blue in tone) or warm (red or orange). In general, pictures look better when the color temperature of light is warm. This is why photographers refer to the hours around sunset and sunrise as the "golden hours."

108 Contrast

When we look at a scene our eyes automatically compensate for different levels of brightness and we can see detail with a high degree of latitude. The camera, on the other hand, can't record detail in the same range of highlights and shadows, so in a high contrast scene it may struggle to capture the same detail that you can see.

109 Reducing contrast

On a bright, sunny day you can soften hard, contrast-rich lighting by placing a diffuser between the sun and your subject (see illustration opposite, right). This will have the same effect as if the weather conditions were overcast.

110 Controlling color temperature

You can change how the camera records the color of light by adjusting the camera's WB or by using color correction (CC) filters. Setting WB to the "cloudy" or "shade" settings, or adding an 81-series orange filter to the front of the lens will make your pictures warmer in tone. For the opposite effect, set WB to "natural daylight" or "incandescent," or use an 80-series blue filter.

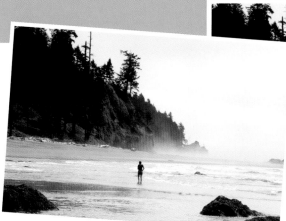
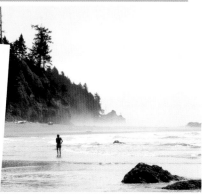

You can use the white balance setting to adjust how the camera records light temperature to get the result you are after.

Contrast from bright light and shadow helps to give the landscape a sense of depth.

111 Lighting for landscapes

Contrast-rich conditions are nevertheless considered better for landscape photography as the range of shadow and highlight areas helps to create depth.

A diffuser reduces contrast in over-bright conditions (right).

Soft lighting is always better for portraits (below).

112 Weather

On cloudy days, the level of contrast in a scene is less than when the sun is shining. Other weather elements that reduce contrast are mist, haze, and fog.

113 Lighting for portraits

Soft, diffused lighting, such as daylight on an overcast day or flash lighting directed through a soft box or umbrella or bounced from a light surface, is generally considered the best type of lighting for portrait photographs of people.

Direction of light

The direction from which light falls on a subject will dictate how surface detail appears (whether relatively flat or textured) and how and where shadows fall (determining the sense of depth). You can exploit this for artistic effect, creating silhouettes or beautiful golden "halos" around people or animals.

Sidelighting

Light falling from the side, relative to the subject, will help give your pictures a strongly three dimensional appearance. Sidelighting accentuates shadows, and this helps to create depth.

Sidelighting (above) is best for portraits; backlighting (right) can create effect.

Texture

Because sidelighting creates contrast, it is the best lighting for accentuating surface texture in material such as the bark of a tree or the patterns on leaves.

Frontlighting

Frontlighting is generally considered to be poor in quality as it produces very flat pictures lacking in contrast and shadow.

118 Backlighting

Although you are often advised against photographing into the sun, lighting from behind the subject can produce very strong graphic images. Use it to create silhouettes and rim-light effects.

119 Seasons

During late fall, through winter, and into early spring the sun is never fully overhead and light falls on the land from the side. In summer, on the other hand, the sun rises more quickly and far higher in the sky.

120 Seasons for landscapes

Winter is often considered the ideal season for outdoor photography because the sun is at a low angle, creating lighting conditions that are perfect for emphasizing form, texture, and depth.

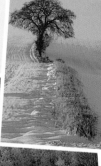

121 Coping with reflections

To remove reflections from shiny, nonmetallic surfaces such as water and glass, use a polarizing filter.

A polarizing filter helps to reduce unwanted reflections.

Composing the picture

After good lighting, the next most important factor is composition. Where you stand, how you hold the camera, and what you include and exclude from the scene all add up to whether you finish with masterpieces to hang on your wall.

A meandering river calmly leads the eye into the picture space.

122 Leading the eye

What you are trying to achieve with good composition is a combination of balanced elements that lead the viewer from one part of the picture to another in an organized fashion.

123 Format

Digital cameras have two formats: vertical and horizontal. If you hold the camera in its normal position, the horizontal format applies. Holding the camera on its end will give you a vertical composition. The format you choose to use will alter the emphasis of the photograph.

125 Horizontal

The horizontal format is sometimes referred to as the "landscape" format because it is very well suited to landscape subjects. Holding the camera in the horizontal format will emphasize width and space.

126 Two for the price of one

Take each picture in both horizontal and vertical formats. You can then decide which you prefer when you later come to process your images.

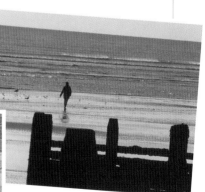

124 Vertical

The vertical format is also known as the "portrait" format because photographs of people often look better when shot this way. Holding the camera in the vertical format will emphasize height.

127 Subject position

Once you've decided on the most appropriate format, you'll need to choose where you place the main subject in the photograph. And, once again, your decision will determine the emotional impact of the picture.

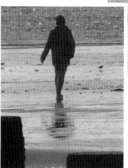

Horizontal and vertical formats give different emphasis.

128 Edge of frame

Avoid positioning the subject too close to the edge of the frame because it can make the picture appear unbalanced and poorly composed.

131 Center

Positioning the subject in the middle of the picture space will hold your gaze on the center, which is entirely appropriate if what's there is the most interesting and important part of the picture.

134 Direction of vision

In the West we read from left to right and from top to bottom. Following this (to us) natural orientation when designing a picture will produce a more aesthetically pleasing result.

129 Rule of thirds

This is a well-known photographic technique that really works. The principle is to divide up the picture frame by drawing imaginary lines at one-third intervals, horizontally and vertically across it. The focal point of the image should fall where lines intersect. This creates an asymmetric design that produces tensions and relationships between the pictorial elements, giving a more dynamic and visually energetic structure.

132 Using lines

Straight horizontal lines provide a sense of wellbeing and calm because we associate them with our natural point of orientation—the horizon. Vertical lines accentuate height and diagonal lines create visual energy.

Lines can be used to lead the eye or to create visual energy.

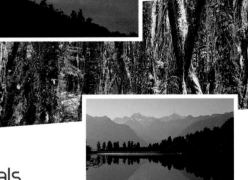

A symmetrical picture (top) creates a sense of calm, while asymmetry (bottom) creates tension.

130 Symmetry and asymmetry

Symmetry and asymmetry will dictate the visual weight of your pictures. A balanced (symmetrical) picture tends to create a sense of tranquillity and/or stability, while an unbalanced (asymmetrical) image appears more dynamic.

133 Spirals

Composing picture elements so that they spiral out from a central point will produce visually energetic photographs, even if the subject is static.

135 Triangles

Triangles make us think of stability and permanence. They are also symbolic of mystical power, as denoted by Egyptian pyramids and by mountains such as Everest and Fuji. Pointing upward, triangles always imply strength, although the opposite is true when they point down.

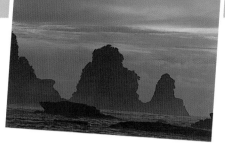

Lenses and composition

136 Focal length

Changing the focal length of the lens, either by changing lenses or by altering the zoom setting, will also change the way we relate to the objects within a picture. In 35mm equivalency, a 50mm lens (around 75mm in digital terms) gives a familiar perspective.

137 Wide-angle lenses

Wide-angle lenses will reduce the size of the main subject and give the optical illusion of expanding the distance between objects. They tend to create a greater sense of space and depth—and so are good for landscape photography.

138 Telephoto lenses

Telephoto lenses increase the size of the main subject and compress the space between foreground and background. They are ideal for portraits (where the background is often secondary) and wildlife or sports subjects (where it is difficult to get close enough for frame filling images).

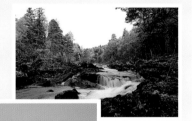

Wide-angle lenses create space (above), while telephoto lenses bring subjects closer (left).

139 Perspective

Perspective helps to define the way we see a photograph. There will be no big surprises in a picture taken from a normal standing position, while altering your position—getting low down or up high, for example—helps to create visual effects that jar the sense of normality and communicate a view of the world that others rarely consider.

Changing your perspective makes for more interesting pictures.

140 A sense of place

Including background and/or foreground features will give your subjects a sense of place, relating them to their surroundings.

141 Depth

Photographs are two-dimensional images of a three-dimensional world, so you need to arrange the picture elements to give the illusion of depth. You can use contrast and well-defined shadows, or converging lines, such as roads, pathways, and railway tracks. Alternatively, include foreground, middle ground, and background.

142 Patterns

Look for pictures within pictures. Patterns, from a rhythmic repetition of shapes, and texture will both create abstract designs and give your photographs a tactile quality.

143 Isolation

If you want to place all the emphasis on the subject, then you will need to isolate it from its surroundings, either by using a very shallow depth-of-field or by cropping in tightly to eliminate background and foreground features.

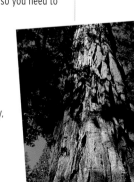

144 Color

Colors have a strong influence in photography. Used together, they can either add to, or subtract from, the compositional strength of the picture.

145 Primary and pastel colors

The strong primary colors—red, blue, and yellow—grab attention and are what you see first in the photograph. If they are not the main subject feature, then they will lead the eye away from the main point of the photograph. Pastel colors are calming and set a mood of tranquillity.

146 Complementary colors

Some colors work better together than others. Red and green (which are complementary colors) put together have a physical effect that helps to achieve visual energy and three-dimensional form. Other color pairings that work well are blue and orange, and yellow and violet.

Red and green subjects appear more vivid when placed together.

147 Cropping

DPSs are a particular size and will capture light over their entire surface. However, this size frame may not be ideal for the image you are trying to create. Never be afraid to frame the subject with cropping at a later date in mind. For example, some landscapes are better suited to a panoramic format and portraits of people often look better as a square format.

149 Making a statement

Photography is a form of graphic storytelling. Giving some thought to the story you want your pictures to communicate before taking them is a professional technique that leads to consistently better photographs. Humor, happiness, sadness, thoughtfulness, danger, action, interaction, cutesy behavior, and a sense of place are examples of different "stories" your pictures may tell.

148 Framing

A well-known compositional technique is to frame the main subject within the picture. You can use naturally occurring objects such as the outward arc of a tree branch, or props such as a window frame. Using frames in this way will focus attention on the subject and hint at a wider sense of place.

Try to capture the emotion of the moment in your picture.

Handling the digital camera

After good lighting and strong composition, the next stage in capturing the image that you want is to get your camera to do what you want it to do—and to do it well. The following tips will enable you to be master of your camera.

150 Get to know your camera

Whether it's a point-and-shoot or hi-spec DSLR, get to know how your camera works. Become intimately familiar with the position of dials for everyday functions, zoom and lens control, focusing, changing lenses, setting exposure, WB and ISOE settings, so that operating them becomes second nature. Doing so will make sure you never miss those once in a lifetime candid moments.

151 Using the viewfinder

Hold the camera close to your eye and set the image so that your subject is where you want it within the frame. Then scan the whole area of the viewfinder to check for unsightly objects, such as an electrical pylon, trash, or a tree apparently sprouting from the top of your subject's head. Only when you're satisfied everything is just right should you take the picture.

152 LCD viewfinders

Avoid cameras that only have an LCD screen to compose your pictures. They are difficult to use for precise framing; the image appears very jumpy, and they use a lot of battery power. If you do use the LCD screen, use the camera with a tripod.

153 Batteries

Always carry a spare set of batteries. There's nothing worse than finding a great composition with superb lighting only for your camera to pack up because your batteries have died. In very cold weather, keep a set of spare batteries in an inside pocket so that your body heat will keep them warm and fully operational.

154 Camera shake

Camera shake, caused when the camera is moved as the picture is taken, shows on the resulting image as soft edges and blur. Avoid it by setting a fast shutter speed or, preferably, using a solid camera support, such as a tripod.

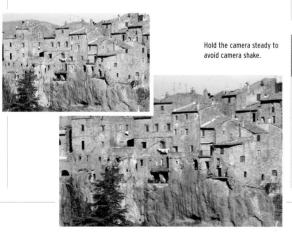

Hold the camera steady to avoid camera shake.

155 Handholding

When handholding the camera, first make sure you are comfortable and hold the camera with your arms tight in to your body for the best support. If possible (i.e. if your composition allows), keep your center of gravity low by kneeling down or by lying on the ground. When standing, keep your feet slightly apart.

156 Using supports

If there are any natural supports around, such as a tree, wall, fence, or post, then use them to help steady the camera while you are taking the picture.

157 Pressing the shutter

Before you press the shutter, take a deep breath and take the picture as you're breathing out, when your body is at its most relaxed. Doing this will help to avoid jolting the camera, which may cause camera shake.

158 Using a tripod

Ideally, use a tripod. While this isn't always possible, it can be essential for some areas of photography, such as low light and landscapes. As with handholding the camera, keep the tripod's center of gravity low by extending the legs to just the minimum acceptable length required to get your shot. Never extend the center column unless absolutely necessary, as this is the weakest part of the tripod.

159 Balancing the camera

With long lenses, the camera will become unbalanced if the tripod is attached in the usual way to the camera's base. Most long lenses have a tripod collar that allows you to attach the lens to the tripod head, making for a more stable support.

160 Weighting the tripod

In windy conditions, particularly with lightweight tripods, it is a good idea to weight the tripod down by hanging a heavy bag from the unextended center column. Some tripods have a special hook and custom bag for exactly this purpose. The advantage is a much steadier tripod and better image quality.

161 Self-timer option

If you don't have a remote shutter release then one option is to use the camera's self-timer function. Set the camera on the tripod and compose the picture. Then set the self-timer and fire the shutter in the normal way, remembering to remove your finger from the shutter release after doing so. When the timer goes off the shutter will activate and, hey presto, blur free images.

162 Remote shutter release

When you use the camera with a tripod you should, ideally, trigger the shutter with a remote release. This stops the pressure of your finger on the shutter release button from jolting the camera.

163 Mirror lock-up

For landscapes and static subjects it's wise to use the camera's mirror lock-up function. This is usually activated via the menu options and will flip the mirror up out of the way of the shutter curtain before activating the shutter release. This helps to minimize any camera shake caused by vibration when the mirror moves. (This tip is relevant only to DSLRs, as compact cameras have no reflex mirror.)

Which file type?

Most digital cameras offer more than one option of file type. The advantages and disadvantages of each type are discussed below.

 TIFF

Tag image file format is a standard format and the best option for images used in print reproduction. The main disadvantage is the very large file sizes, which means fewer images can be stored on the memory device. It is possible to compress TIFF files without losing any data (referred to as lossless compression), although this will also slow down file opening times.

 RAW

A RAW picture file takes data directly off the digital sensor. This data is unprocessed and the result is very high-resolution images that can be altered on the computer via proprietary software as if the changes had been made in-camera.

 JPEG

This format can reduce file sizes down to as little as 10 percent of their original size, allowing faster transmission and enabling more images to be saved on the memory device. The disadvantage of the JPEG file format is image quality. Because of the way the files are processed, some of the original data is irretrievably lost. However, there are options for different quality levels, which can either reduce or increase the level of data lost, depending on how you intend to use the image. For example, a high setting of 9 or 10 will give high quality images, suitable for reproduction purposes, while for general use a middle setting of 5 or 6 will give good results without any obvious loss in image quality.

Using Filters

There are two types of filter: technical filters and creative filters. Creative filters are only a poor attempt to make dull subjects interesting.

 Screw-in filters

Some filters screw onto the front of the lens while others use a filter holder. For the screw-in variety, the lens needs a filter thread, which is often not the case with compact cameras. Filter systems work by attaching a filter holder to the camera, either via the lens or via the tripod mount. Into this you slide the square or rectangular filters. The advantage of this type of system is that one filter will fit all your lenses, whereas with screw-in filters if your lenses have a different front diameter then you'll need another filter to fit.

There are two types of filter: those that screw onto the lens (left) and those that use a holder system (above).

168 Buy big

Filters themselves come in different sizes, often referred to as "amateur," which are smaller, and the larger and slightly more expensive "professional." I recommend going with the larger size system straight away as it won't be long before you find that amateur filters are too small for some of your lenses–particularly very wide-angle and long telephoto lenses, and some extreme zooms.

169 Buy the best

The money you spend on superbly refined optics for your camera will be wasted if you stick a piece of cheap plastic in front of the lens. Always buy quality filters from reputable manufacturers.

172 Ultraviolet (UV)

UV filters remove the invisible ultraviolet light that we can't see but that cameras record. They filter out atmospheric haze in landscape pictures, particularly if taken at altitude, e.g. from an airplane or high up on a mountain. Some photographers keep them on at all times because the filter (which is relatively cheap) protects the (expensive) lens from dirt or damage. However, consider the effect on image quality (tip 170).

UV filters are useful at high altitude.

170 Image quality

Filters are an extra piece of glass (or, more often, plastic resin), and another surface that the light has to pass through on its way to the DPS. Unless that extra surface is adding real value to the final image, it's best to keep it out of the way.

171 Cleanliness

Just like your lenses, filters have to be kept absolutely clean. If you don't look after them, scratches, dust, and dirt will show up in poor image quality.

173 Warming

The 81 series of warm filters are used extensively by landscape photographers with film cameras, but are less necessary in digital photography because white balance (WB) can achieve the same effect more easily. They give an orange, or warm, cast where the light is very blue, during the middle of the day or in overcast or shady conditions. Setting the WB to either "cloudy" or "shade" will achieve the same effect.

174 Neutral density (ND)

Neutral density filters work by reducing the amount of light entering the lens without changing the color cast. They are particularly useful in very bright conditions when, for compositional reasons, you want to use a larger aperture than the prevailing light level would otherwise allow (e.g. to reduce depth-of-field) or a slower shutter speed (e.g. to blur motion).

A warm filter will give your pictures a more "golden" appearance (main image).

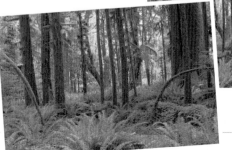

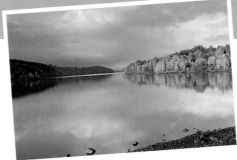

175 Neutral density graduated (NDG)

This is a variation on the straight ND filter. With an NDG filter the tone darkens gradually from clear to full strength across the filter. This is useful when one part of the scene is much brighter than another—for example, in a landscape where the sky is very bright and the foreground is in dark shadow. Placing the ND (dark) part of the filter over the sky area reduces the amount of light entering the lens from that part, evening up the tones between the sky and the dark foreground so that your exposure is easier to manage.

NGD filters will even out areas of light and shade.

176 ND & NDG filter strength

These filters come in different strengths, measured in stops. So, if you wanted to reduce your exposure by one stop, for instance, then you would use a one-stop ND or NDG filter. The table (right) lists each filter and its equivalent strength.

Filter	Stops
.3	1
.45	1.5
.6	2
.75	2.5
.9	3

177 Polarizing Filters

Polarizing filters can be used to saturate colors.

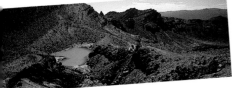

These filters polarize the light entering the lens. They:
- remove the unwanted reflections from shiny non-metallic surfaces, such as water and glass
- darken blue skies and make white clouds more prominent
- can be used to good effect on foliage, which reflects non-polarized light, particularly when wet
- will intensify the color of glossy objects, such as glazed ceramic tiles and shiny plastics.

178 Linear and circular polarizers

There are two types of polarizing filter: linear and circular. Both affect light in the same way but a linear polarizing filter will affect your camera's AE and AF functions. To use TTL-metering and/or auto-focus, you need to use a circular polarizing filter.

179 Polarizing filters and exposure

As polarizing filters reduce the amount of light entering the lens—depending on the filter position—compensation is needed:

Polarization	Compensation
1/4	+ 1/2-stop
1/2	+ 1-stop
3/4	+ 1 1/2-stops
Full	+ 2-stops

180 Bracketing

It is always worth bracketing exposures when using a polarizing filter (see tip 206).

181 Compact cameras

With a compact camer, the positioning of NDG and polarizing filters is critical for accurate composition. Use the LCD panel to assess where to position these filters in relation to the subject and the light source.

You can get special holders for using filters with compact cameras.

Spot-on exposures
When reflected light falls on a light-sensitive material an image will form on it. Photographic life is a little more complicated than that, however, and the next step is determining just how much light you need to allow to fall on the DPS and for how long.

Getting exposure right means understanding the exposure controls.

182 Exposure explained

Exposure is the science of getting just the right amount of light to reach the DPS for exactly the right length of time given the ISOE set. Too little light will result in underexposure–a dull, dark image lacking detail in shadow areas. Too much light will result in overexposure–a washed-out image lacking detail in highlight areas.

183 Controlling exposure

Digital cameras have three main functions for controlling exposure: lens aperture, shutter speed, and ISOE.

184 Measuring exposure

The standard measurement for exposure is the stop. Any change in ISOE rating (see tip 188), lens aperture, or shutter speed is referred to as an n-stop change, where n equals the degree of change. For example, ISOE 400 is referred to as being one-stop faster than ISOE 200; a change in lens aperture from f/5.6 to f/8 is considered a one-stop change in lens aperture; and a change in shutter speed from 1/125th of a second to 1/250th of a second is considered a one-stop change in shutter speed.

185 Underexposure

To correct underexposure you can either increase the lens aperture or slow down the shutter speed, or a combination of the two. Alternatively, you can increase the sensitivity of the DPS by increasing its ISOE rating, effectively causing the DPS to need less light in order to form an acceptable image.

186 Overexposure

To reduce the level of light, you can reduce the lens aperture or increase the shutter speed, or a combination of the two. Similarly, you can alter the sensitivity of the DPS so that it will react more slowly to light.

187 Reciprocity

To keep exposure value the same, any change in lens aperture necessitates an equal and corresponding change in shutter speed (reciprocity law). If correct exposure setting is 1/60th of a second at f/4 and you decide to alter the shutter speed to 1/125th of a second (halving the time light falls on the DPS), you should increase your aperture to f/2.8 (doubling the amount of light). If you decrease the aperture from f/4 to f/5.6, halving the amount of light reaching the DPS, you need to reduce your shutter speed from 1/60th to 1/30th.

188 ISOE rating

ISOE is the measurement of a DPS's sensitivity to light. ISOE 200, for example, reacts more slowly to light than the higher ISOE 400, so that more light is needed for a longer period for an image to form. ISOE rating affects exposure time by determining how quickly the DPS reacts to light.

189 ISOE and digital noise

Digital noise occurs because of the electromagnetic properties of the DPS and appears as unrelated and adjacent pixels. It produces a similar appearance to the grain of photographic film. The bigger the enlargement of the image, the more noticeable the noise becomes.

For a clearer image, digital noise can be reduced by using the Noise Reduction Function on some cameras.

190 Digital noise and shutter speed

At fast shutter speeds the proportion of noise relative to image pixels is very small and therefore generally can't be seen. However, the longer the DPS is active (i.e. exposed to light), the greater the ratio of noise to image pixels and the more obvious it becomes.

191 Noise reduction

Some cameras come with a "noise reduction" option specifically for use in long-time exposures. I would highly recommend using this when your shutter speeds exceed one second.

193 F/stops

All camera lenses are calibrated to the same scale of measurement known as f/stops. These can be seen on the lens aperture ring of interchangeable lenses, or are marked on the outer lens ring on compact cameras. The set aperture may also be shown in the top LCD panel of a DSLR.

192 Lens aperture

The lens aperture controls the amount of light reaching the DPS. It works in the same way as the pupil in the human eye. In very bright conditions the pupil contracts, as it needs less light to distinguish detail. In very dark conditions, the pupil gets bigger because it needs more light to distinguish detail. Changing the size of the lens aperture allows more or less light into the camera.

194 Changing f/stops

Increasing the aperture by one full stop will double the amount of light reaching the DPS. Inversely, reducing the aperture by one full stop will halve it. In most compact cameras the f/stop is fixed or limited by the camera, whereas DSLRs have a full range of manually adjustable f/stop settings.

195 Depth-of-field

Controlling exposure via lens aperture will affect depth-of-field. The larger the aperture, the less depth-of-field you have, while reducing the aperture increases it. This affects the final image, and must be taken into account when setting exposure values.

Lens aperture controls depth-of-field.

200 Exposure compensation

If your camera has an exposure compensation function you can dial in the amount of compensation required and leave the camera on the AE setting. It will then automatically adjust the exposure by the amount of compensation set.

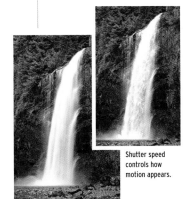

196 Shutter speed

Measured in fractions of seconds, shutter speed defines the length of time light falls on the DPS. A full one-stop change will either double or halve the length of time the shutter is open. Increasing from 1/125th of a second to 1/250th (one stop) halves the time the shutter is open, and decreasing one stop from 1/125th of a second to 1/60th doubles it.

Shutter speed controls how motion appears.

201 Middle tones

The camera's light meter gives an exposure setting for a middle-toned subject. If you use this setting without compensating for the relative brightness of your subject it will appear middle-toned in your picture. The extremes of white or black will both look gray, as the camera tries to make light subjects darker and dark subjects lighter.

Light meters are calibrated so that they give a middle-tone reading.

197 Effects of shutter speed

By adjusting shutter speed to affect exposure you can control how you depict movement. A fast shutter speed will freeze action, while a slow shutter speed creates blur, giving a greater sense of motion.

199 How light meters work

The meter measures the amount of light on the subject it is pointed at. Some colors reflect more light than others (yellow, for example, reflects far more light than dark green). The camera makes an assumption that that subject is a middle tone, reflecting around 18 per cent of the light falling on it.

202 Compensating for lighter subjects

If your subject is lighter than middle tone (for example a yellow daffodil or the snow) you will need to open up the exposure to allow in more light.

For darker and lighter subjects, you will need to adjust the exposure.

198 Measuring light

Light meters measure the amount of light for accurate exposure. They vary from the fairly simple in low-spec compact cameras to database driven multipattern in most DSLRs.

203 Compensating for darker subjects

If the subject is darker than middle tone you will need to close down the exposure to allow in less light.

High-contrast conditions
On a bright, clear day the shadows and highlights can fool your camera's meter. There are various ways of compensating.

204 Sunny f/16 setting

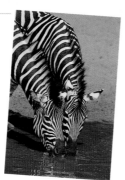

One solution is the sunny f/16 rule, which means setting lens aperture at f/16 and shutter speed at the setting closest to that of the ISOE rating you're using. With ISOE 200 the exposure setting using the sunny f/16 rule would be f/16 @ 1/200th. From this base setting you can work out any equivalent combination of settings. (Here, you could also use 1/400th @ f/11 or 1/100th @ f/22.)

205 Sunny f/22 setting

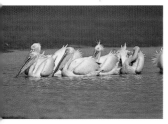

Use the sunny f/22 rule for very bright subjects on a sunny day.

For white subjects under very bright conditions, where the subject fills a large part of the frame, the sunny f/16 rule results in detail being lost in the highlights. Here, the rule to use is the sunny f/22 rule. This works in the same way but the base lens aperture setting is f/22. Reducing the level of light reaching the DPS by half will darken the highlight areas of the image and add detail. As with the sunny f/16 rule, once you have determined the correct shutter speed at f/22 you can use any equivalent combination of settings.

207 Using exposure to set mood

Every change made to the camera's exposure settings will change the way the final image is recorded. This will affect depth-of-field, motion blur, and digital noise, and also the mood and emotion conveyed and the graphic statement made by the photograph. The variations may be so subtle as not to be apparent to the uninformed observer. But they make the difference between a good picture and a compelling one.

Exposure compensation guide

White (in bright sunlight) Snow, swans' feathers +2.5	Pink Fuchsia flower +1	Medium red London bus, poppies +/-0
White (in overcast conditions) Snow, swans' feathers +2	Light blue Early morning, clear sky +1	Medium blue Midday clear sky +/-0
Bright yellow Daffodil +1.5	Flesh color White human skin +1	Dark green Conifer tree -1
Gold Jewelry, sand +1	Medium green Lawn green +/-0	Deep violet Violet flower -1
Orange Orange fruit +1	Medium brown Redwood tree bark +/-0	Black Coal, black dog or cat -2 to -2.5

206 Bracketing

Bracketing means taking two or more of the same picture at different exposures, usually around one stop above and below the camera's AE setting. Although you can review images immediately on the LCD screen there are times when you may want to bracket exposures to ensure a good result.

If in doubt, use the bracketing technique to judge exposure.

Focus

As well as getting the exposure right, you must make sure that your subject is in focus. Most cameras now have sophisticated auto-focus (AF) systems, but these can easily be fooled.

Foliage can confuse AF systems. Switch to manual focusing for best results.

208 Off-center subjects

If your subject falls outside the focus detector in the viewfinder, the camera will focus on something else, which may leave you with your principal subject out of focus.

210 Fast moving subjects

When photographing fast moving subjects it can be better to pre-set the focus, wait for the subject to move into the frame of focus, and then take the picture.

209 Getting off-center subjects sharp

Using the viewfinder, center your subject in the AF detector. (In compact cameras, this is usually the center of the viewfinder; with some DSLRs you can select different areas of the viewfinder to be the active AF sensor.) Press the shutter release halfway to activate and lock AF. Re-compose the image, then fully depress the shutter release to take the picture.

211 Pre-focusing

Select a point that you know the subject will pass through. Focus on this point by depressing the shutter release halfway to lock AF and wait for the subject to enter the frame. When it reaches the point of focus, fully depress the shutter button.

212 Obscure objects

Objects in front of, or behind, the main subject can interfere with the AF system. This is particularly so if, for example, you are looking through foliage or a fence.

213 Focusing through glass

If you are trying to focus through glass (e.g. a window or screen), reflections on the glass may confuse the AF sensor.

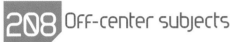

Use pre-focusing techniques for fast moving subjects.

214 The plane of focus

There is only one absolute plane of focus. Anything in front of or behind that plane will be out of focus—although it may appear to be acceptably sharp if there is enough depth-of-field.

215 Depth-of field

Depth-of-field is the area in front of and behind the plane of focus within which objects appear acceptably sharp. How far this area extends depends on three things:
• the lens aperture used
• the focal length of the lens
• the camera-to-subject distance.
Anything outside the range of available depth-of-field is blurred.

216 Lens aperture

Depth-of-field increases as lens aperture gets smaller (denoted by a higher f/number)—so a lens aperture of f/16 will give greater depth-of-field than an aperture of f/11. It will be at its minimum with the aperture wide open (smallest f/number), and at its maximum when the aperture is set to the smallest setting (highest f/number).

217 Lens focal length

The focal length of the lens will also affect the depth-of-field. Smaller focal length lenses, such as a wide-angle lens (e.g. 20mm), will produce more depth-of-field than telephoto lenses (e.g. 200mm). Therefore, depth-of-field will be greater on a 28mm lens set at f/8 than on a 200mm lens set at the same aperture.

219 Using depth of-field

Depth-of-field can be used as a compositional tool to help convey your visual ideas. For example, you can use it to create a sense of place, to isolate subjects, or to define the relationship between distant objects within a scene.

218 Camera-to-subject distance

The farther from the camera the subject is, the greater the depth-of-field available. Consequently, depth-of-field is very limited in close-up and macro photography.

220 Acceptable depth-of-field

What we perceive to be acceptable sharpness varies depending on the extent of the visible blur, which, in turn, will depend on the size of the enlargement. The larger you intend to make the final print, the greater the depth-of-field required.

A small aperture gives increased depth-of-field.

221 Hyperfocal distance

The hyperfocal distance is the focus setting that gives maximum depth-of-field for any particular lens aperture. This is a simple and effective technique, although it can only be achieved with a lens that can be manually focused. To set the hyperfocal distance, first set the lens focus to infinity (denoted by the (marking on the lens barrel). Then, using the depth-of-field index on the lens barrel*, note the nearest point of acceptable sharpness for the aperture you're using and adjust the focus to this distance. You have now achieved the hyperfocal distance.

* Many zoom lenses do not carry a depth-of-field index, in which case you'll need to use the depth-of-field preview button on the camera (if there is one), or refer to the depth-of-field tables in the lens manual.

HOW TO PHOTOGRAPH...

Landscapes

Getting away to the countryside sometime soon? Then you'll want to capture those perfect sunsets and the wild beauty of the landscape.

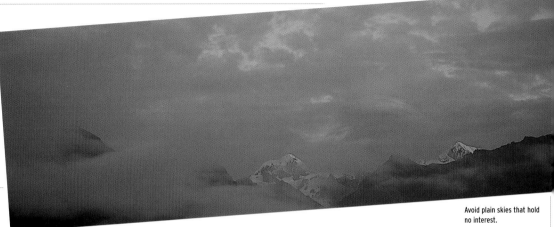

Avoid plain skies that hold no interest.

222 Depth-of-field

Landscapes should, in general, be sharp from the closest point to infinity. Set a small lens aperture, such as f/16 or f/22, to ensure good depth-of-field and use the camera's depth-of-field preview button (if it has one), to check whether all areas of the picture space are sharp.

223 Skies

Avoid uninteresting skies, and try to include, for example, white puffy clouds against a blue sky. If the scene is worth photographing, even with a dull sky, minimize the amount of picture space the sky takes up by lowering the angle of the camera to include more foreground.

226 Pictures that flow

Use other subjects within the picture space to keep the viewer's eye moving from one point to the next. This helps to give the photograph a sense of purpose, and it also creates visual energy, which enhances the compositional strength of the picture.

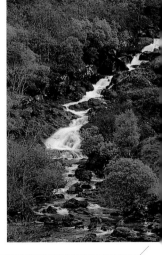

224 Hyperfocal distance

To maximize depth-of-field you can use the hyperfocal distance technique described on page 51.

225 Foreground interest

Visually, a good landscape photograph should "read" like a story. It should have a beginning, a middle, and an end. Try to include some foreground interest, such as a boulder or a fence post, to help lead the viewer's eye into the picture.

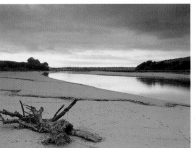

Give landscape pictures foreground interest.

Good landscape pictures lead the eye from one part of the image to the next.

227 Positioning the main subject

In landscape photography the rule of thirds (described on page 38) is an effective compositional tool that always makes a good point to start from.

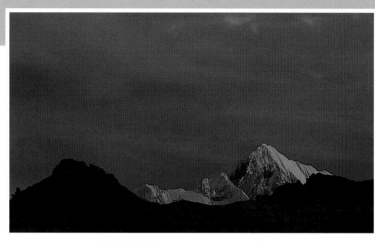

Use the rule of thirds when composing landscape images.

228 Tripods

Use a tripod whenever you can. This will ensure that you avoid blur from camera shake and it is an essential tool in framing your landscape compositions.

229 Creating visual energy

Because landscapes are static subjects, they look more appealing if you can create visual energy. This is done partly through how you position subjects in relation to each other, but you can also use diagonal lines, include an odd number of subjects in an asymmetric design, or combine complementary colors, such as red and green.

230 Weather

Sunny weather isn't a prerequisite. Excellent pictures can be made in stormy conditions, and remember to look out for those enigmatic rainbows.

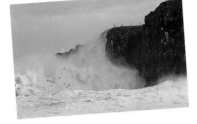

231 Tilting horizons

There's nothing more annoying than taking a great picture, only to find that the horizon isn't straight. We are naturally attuned to straight horizons and a tilting horizon jars our sense of balance. Using a tripod will help and, in extreme circumstances, you can get a small spirit level that attaches to the accessory shoe. If this still fails, page 93 describes a technique to rectify the problem.

You don't always need good weather for good landscape pictures.

232 Silhouettes

Silhouettes make great landscape subjects. The best way to photograph them is to expose for the highlights, rendering the darker areas underexposed. Try to get an even balance between dark and light areas so that the silhouette doesn't completely overpower the picture.

Wait until dusk to create beautiful silhouettes.

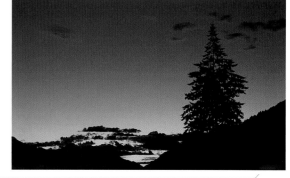

233 Lens flare

With a wide-angle lens with a large front element, or when photographing into the sun, use a lens shade to avoid lens flare.

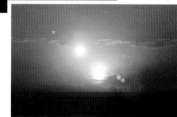

Use a lens hood to avoid lens flare.

234 Depth

Aim to create depth in landscape pictures by using converging lines, such as the flow of a river or even a road, or by encapsulating the shadows and contrast that are created when your subject is lit from the side.

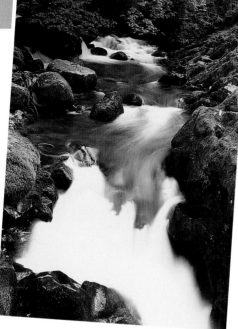

You can exploit contrast to create a sense of depth.

237 Panoramas

Landscape scenes are ideally suited to the panoramic format. You can create panoramic images by composing the picture in an appropriate way when taking it and later cropping to suit on a computer (see page 92).

Landscapes are ideally suited to panoramic photography.

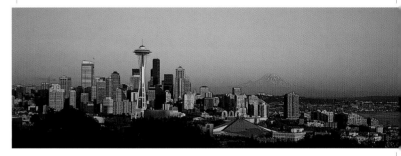

235 The golden hours

Landscape photographers refer to the hours around sunrise and sunset as the "golden hours" because the low angle of the sun creates very warm lighting with a golden glow.

236 White balance (WB)

The best WB setting for landscape photography in natural light is either "cloudy" or "shade." These settings will give your pictures a slight orange color cast that warms up the picture in the same way as using an 81 series filter. On well-lit days with overcast conditions, set WB to "cloudy." On darker days, when shadows are stronger, set WB to "shade."

238 Middle tones and exposure

The best way to expose for landscapes is to find an area of the scene that is a middle tone, such as a patch of green grass or a late-morning clear blue sky, and take your meter reading from that point. If the brightness range of the rest of the scene is within the DPS's latitude range, the whole picture will come out well exposed.

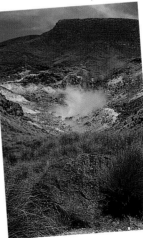

239 Assessing subject brightness range (SBR)

To assess the brightness range of the entire scene, first find the brightest part and take a meter reading (if the camera has a choice of metering modes, use the "spot metering" option). Then take another reading from the darkest area. Apply the appropriate compensation factors for non-middle tone subjects (see page 48), then calculate the difference between the two readings. This is your SBR. If it is less than 9-stops, then it falls within your DPS's exposure latitude.

Look for middle-tone subjects when metering.

240 Extreme contrast

If the SBR (see tip 239) is greater than 8-stops then the contrast will be too great for your camera to record detail in both the highlight and shadow areas. It may be possible to overcome this problem by using an NDG filter, which will reduce the tonality of the brightest part of the scene (see pages 44-5).

Use a polarizing filter to saturate colors.

241 Saturating colors

To make the colors within your landscape scene more vivid, use a polarizing filter, which will give extra punch to strong colors such as reds, oranges, yellows, blues, and greens.

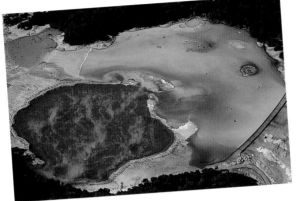

242 Right time

One of the keys to successful landscape photography is being in the right place at the right time. Keep an eye on the weather forecast so you know whether it's worth traveling in the first place. Low pressure usually means wind and rain, while high pressure is a sign of clear skies on the horizon.

243 Right place

Learning to read a map will greatly increase your chances of being in the right place. Look for areas of special interest, such as woods, rivers, and lakes, as well as subjects such as castles and abbeys. Check to see how easy it is to get to the best vantage point for photography–ideally with the sun side-on to your subject.

Animals and wildlife
Everyone loves taking pictures of animals. The trick is to get a picture that is more than simply a "record shot" of a particular species.

244 Frame filling images

Use a long telephoto lens, such as 300mm, or a high magnification zoom setting, e.g. 10x, to get frame filling images of small or far-distant animals.

245 Freezing motion

Unlike landscapes, animals tend to move, and often very quickly. To freeze the motion of a moving animal, use a fast shutter speed, such as 1/250th or above.

Use a fast shutter speed to freeze fast moving animals.

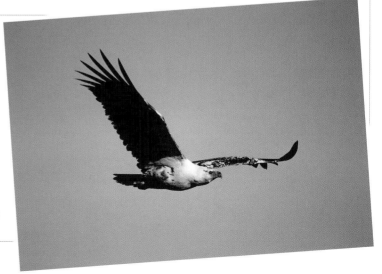

246 Animals in action

Sometimes, rather than freezing motion you may want to emphasize it. To create intentional image blur, set the camera to a slow shutter speed–around 1/10th is ideal–and pan the camera to follow the movement of the animal. Well done, this produces a very emotive image.

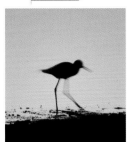
Use a slow shutter speed to depict motion.

247 Focus 1

The most important parts of any animal to get absolutely sharp are the eyes. This is naturally where we first look, and if out-of-focus they will greatly detract from anything else good about the picture. So, when using AF make sure that the focus sensors are positioned on the eyes, or, if the animal is moving around a lot, set a smaller aperture to ensure good depth-of-field (remembering that depth-of-field is less with telephoto lenses).

The eye is the most important feature of any animal to get sharp.

248 Focus 2

The second most important feature is the nose. When it is some way from the eyes you'll need at least some depth-of-field to get them both sharp. One- or two-stops closed from maximum aperture should work.

After the eyes, the nose is the second most important feature to get sharp.

249 Tele-converters

A tele-converter is a less expensive alternative to a big telephoto lens. These fit between the lens and the camera and increase, usually by 1.5 or 2 times, the effective focal length. For example, a 200mm lens with a 2x converter would become a 400mm lens.

250 Stalking

You need to stalk wild animals without scaring them away. Make slow movements, stay as quiet as you can, and try to approach from down wind. Wear clothes that blend with the environment too. Remember that, while our primary sense is vision, often animals rely more on their other senses.

Stalking is an important skill for wildlife photographers.

251 Ethics

No picture is worth endangering the animal you are photographing. Never disturb animals with young and always return any environment you've disturbed to its natural state. Also, never overstay your welcome. If an animal appears agitated then slowly and quietly move away. You can always come back another time. Many countries have laws that extend to wildlife and the countryside and you should make sure you are aware of them before venturing out.

In captivity

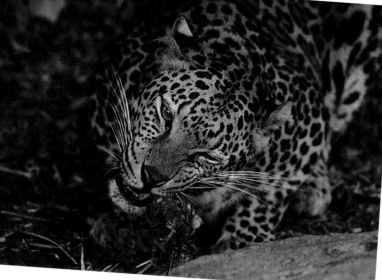

252 Natural settings

When photographing animals in zoos, or at safari parks, try to photograph from a position that gives a natural looking background. Keep an eye out for people or cars in the background, which can spoil an otherwise good picture.

When photographing captive animals, try to make your pictures look as natural as possible.

253 Fences

If you have to photograph through a wire fence, then use a telephoto lens with the aperture set to maximum and put the lens right up against the wire, keeping the hole in the wire central to the front element.* The result will be that the wire is so far out of focus as to disappear altogether.

*This is one time I'd recommend using a UV filter to protect your lens.

254 Eye to eye

If possible, keep the camera at eye level and avoid photographing animals from above their eye line. This will help you gain a much more natural and engaging perspective.

Sometimes shooting from a raised platform is unavoidable.

255 Look for details

The advantage of photographing animals in captivity is that you can often get much closer to them than you can in the wild. This gives you the chance to observe visual details and aspects of behavior you wouldn't normally see. You can exploit this, making your photographs into more abstract compositions.

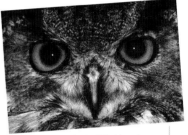

Use fill-flash to capture highlights in the eyes.

256 Flash

Use a small burst of fill-flash on overcast days to add a highlight in the animal's eye. Don't get too close or the flash will overpower natural daylight, causing red- or green-eye.

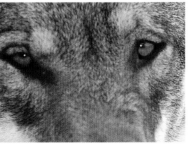

Get up close to capture details of captive animals.

257 Photographing through glass

If you have to photograph through a glass partition, then make sure the flash is switched off. Otherwise, its light will bounce straight back off the glass and ruin your image. If it isn't possible to deactivate the flash then stand at an angle to the glass; this will reduce the likelihood of spoiling your picture with flash flare.

258 Using flash indoors

Some zoos ask you to refrain from using flash in some enclosures, particularly night enclosures, because it may disturb the animals. If you're unsure what the rule is, then check with the zoo staff before using flash.

Catching the character

Animals have a character and personality of their own, and it is this that you should try to capture in the photograph. Here are some things to look out for.

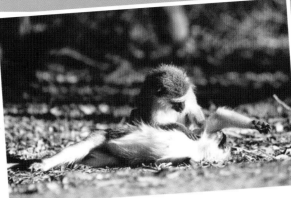

Animal interaction makes for great wildlife pictures.

259 Interaction

Photographing animals interacting will tell the viewer about the relationship between the two (or more) creatures.

263 Action

Photographing an animal in chase, in flight, or simply doing something will give the viewer more information about the subject. This, in itself, always makes the picture more interesting.

264 Sense of place

Animal pictures don't always have to have the main subject filling the frame. Showing the animal's environment will help create a sense of place: something that again conveys more information and again makes the picture more interesting.

260 Danger

Centering a large predator, such as a lion, creates an intense composition that hints of danger.

Capture the lion's predatory character.

261 Humor

Pictures that make us smile are always successful, so be aware of humor.

262 Cute and cuddly

Magazines and calendar publishers love the cute and cuddly appeal of infant animals. It's what's called the "aaah!" factor.

265 Emotion

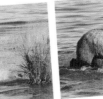

Many animals display very visible signs of emotion. Look out for these to bring the picture to life.

266 Storyboards

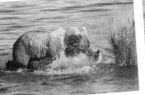

Set your camera to "continuous frame advance" to take a series of images that act like a storyboard to the action.

A running sequence of images helps to tell a fuller visual story.

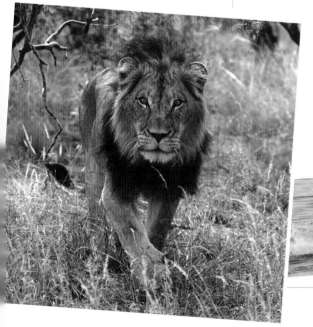

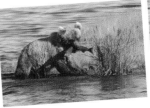

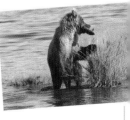

Close-up and macro

Photography is able to reveal things we wouldn't normally see. Seldom is this more so than in the world of close-up and macro photography, where, in a split second, the camera can record a world that is often invisible to the untrained eye.

269 Cameras

Compact cameras really aren't cut out for macro photography. For serious close-up and macro photography you need an SLR camera, largely because for lifesize and larger-than lifesize reproduction you will need a specialist macro lens and possibly specialist attachments such as extension tubes and bellows.

270 Supporting the camera

In photographing at high magnification the slightest movement of the camera will be grossly exaggerated and will make your pictures unrecognizably blurred. Therefore, it is essential to support the camera on a tripod or to supply some other stable and rigid form of support.

268 Macro lenses

Some manufacturers refer to lenses as "macro" if they allow closer than average focusing distances, but these are not true macro lenses because they cannot reproduce the subject at lifesize. This point is worth checking before you buy if you are serious about macro photography.

267 Definition

In true macro photography the subject is reproduced as lifesize on the DPS. There is no fixed technical definition for the term "close-up," but it generally refers to situations where you are working closer to the subject than you normally would.

271 Mirror lock-up

The vibrations of the reflex mirror flipping up out of the way of the shutter can also cause macro images to blur. If your camera has a mirror lock-up facility, then apply it before you take the picture.

272 Depth-of field

Depth-of-field is at a premium when working so close to the subject. Even at very small apertures you will have just a few millimeters either side of the point of focus to work with. Use the depth-of-field preview to check and to gauge the effect of changing the aperture size.

Keep a close eye on depth-of-field when photographing close up.

273 Flash

Flash is often used in macro photography and specialist macro flash units (sometimes known as ring flash units) are available. These gadgets fit on the front of the camera with the lens poking through the middle. They are a good, simple solution but often produce very flat lighting that lacks directional quality.

274 Manual focus

Because focus is absolutely critical, it is far easier to focus the lens manually than to rely on auto-focus. In AF mode you will find that the lens rarely focuses on the correct point.

275 Subject movement

Because available depth-of-field is minimal, even the slightest movement of the subject, caused, say, by a small breeze, can inadvertently render the subject outside the plane of focus. If possible, therefore, try to bring your subject into the studio, where you can control the elements much more easily.

276 Best natural light

If you are photographing outdoors, then avoid the harsh light of direct, overhead sun because the level of contrast it creates is often unsuitable to revealing the minute details you're trying to capture. Hazy, diffused lighting is generally preferable.

277 Twin flash heads

An alternative is to make a twin-flash set-up, using a pair of brackets. This will give you far greater control over the directional quality of the light, helping to accentuate texture and form.

279 Selective sharpness

Quite often it will be impossible to get the whole subject sharp. If so, then the best strategy is to focus on the most important part of the subject, such as the stamen of a flower or the eyes of a creature.

278 Plane of focus

You'll notice that depth-of-field is a bit of a recurring subject in macro photography. In order to maximize the depth-of-field, always keep your subject as close to parallel with the camera as possible. This will help keep more of the subject sharp.

Studio conditions are generally best for photographing flowers.

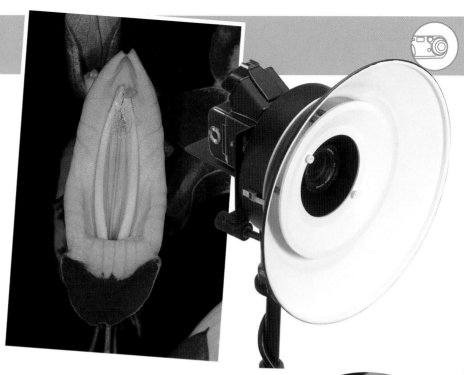

Black backgrounds

If you photograph a subject close-up with flash it is likely that you will grossly under-expose the background, rendering it black. This is ideal if you are trying to isolate the subject and emphasize certain features, such as line or shape. However, it is less pleasing if you want a more natural looking effect. To lighten the background, set the camera to "slow sync" flash mode, which will allow more of the ambient light to register on the DPS.

Choosing a subject
Macro photography allows you to isolate and accentuate very tiny parts of a subject. Flowers, insects, and other minute organisms are the obvious subjects, but here are some other options.

Texture

All surfaces have a texture when you look at them closely and texture makes a fascinating photographic subject. Just look at the rich tapestry of veins on leaves, or the undulating form of tree bark.

282 Pattern

View a butterfly's wing through a macro lens and you'll discover a world of patterns. This is just one example out of thousands that feature has to offer the camera.

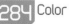 Shape

Shape is another of the principal elements of design that can be emphasized with macro photography. Think about the concentric lines of a snail's shell or the gentle curve of an unfurling rose.

Color

Striking, bold colors, such as red, purple, and yellow, can make fascinating photographic subjects in themselves, particularly when pictured together in abstract form.

Capturing your subjects' emotions will improve your people portraits no end.

People and portraits

People are probably the most popular photographic subject. Here's how to shoot them, whether it be family and friends or candid portraits of strangers, at work or play.

285 Emotions

Aim to catch something of the character of the person you're photographing and to show a particular mood, emotion, or personal trait. Don't think this has to be "happy"—there is a whole range of emotions that will add significance to photographs that you will value in the years ahead. Look out for expressions that are mischievous, sad, thoughtful, amorous, joyful, intense, relaxed, and humorous.

286 Expressions

Most people immediately tense up and stop "being themselves" in front of a camera, but the aim is for them to look natural and relaxed. To elicit natural facial expressions try chatting with your sitter or interacting in some way to keep them feeling relaxed.

289 Get in close

A common error is standing too far back so that the person becomes insignificant in the surroundings. Get up close so that the subject fills most of the frame. For a head and shoulders shot, aim to be within 10 feet (2–3 meters) of the subject and for a full-length portrait, no more than 16 feet (5 meters). If this feels uncomfortably close, use a short telephoto lens, such as 100mm, or zoom in with your compact camera, to achieve the same result.

Resist the temptation to stand too far back for frame filling images.

287 Children as subjects

Children can get easily bored so you'll need to keep them entertained in some way if you want to hold their attention (although a picture of a bored child can have a charm of its own).

288 The eyes have it

The eyes are the most important feature of any portrait—they can display a range of emotions from happiness to sadness, contentment to anger, anxiety to calm. Make sure the eyes are sharp and well lit so that their sparkle shines in your pictures.

Use good lighting to add sparkle to a subject's eyes.

290 Backgrounds

When your attention is on the main subject it's easy to forget the background. Look out for distracting clutter that will draw attention away from the subject, and for those telegraph poles growing out of the tops of people's heads.

 ## Hands

When being photographed, people are often at a loss as to what to do with their hands, which end up looking unnatural. Check whether the hands look natural. If not, then get your subject to relax and see where the hands fall then–this is usually the best place for them. Alternatively, give your model something to hold.

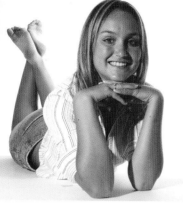

Make sure the hands are in a natural pose.

 ## Framing

Giving your subject a frame, such as an overhanging tree branch, window, or doorway, will help to divert attention from the background and center it on the subject.

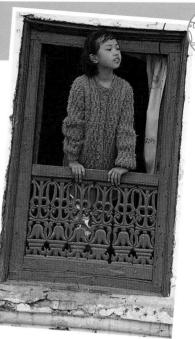

Framing your subject will improve the composition.

 ## Direct sunlight

Bright overhead sunlight is very unflattering, casting ugly shadows, particularly around the eyes (sometimes referred to as "panda eyes"), and under the chin and nose. Overcast weather is ideal for outdoor portraits. In bright sun, wait for the sun to go behind a cloud, or move your subject into a shaded area, such as under a tree or next to a north-facing wall.

294 Silhouettes

Silhouettes make striking and dramatic images.

People in silhouette can create emotive pictures. The key is to follow the contre jour technique (tip 295) but to expose for the bright background, rather than the subject. Do this by taking a meter reading of the background without the subject in the picture and locking the AE setting by pressing the shutter release halfway. Recompose the picture with your subject in position and shoot.

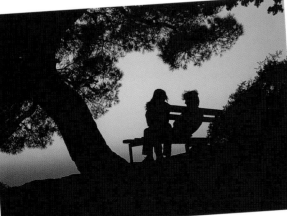

 ## Contre jour

Photographs should normally be taken with the sun behind you. However, for effect, you can deliberately turn the subject so that you're photographing into the sun–a technique known as contre jour. This is not a simple technique, because the light will often fool the camera's meter. But, done well, it can produce some fantastic images with a beautiful halo of light around the edge of the subject.

 ## Contre jour exposure

To keep the subject properly exposed in this situation, take a spot meter reading from the face or use exposure compensation of around +1 or +1.5 stops, and check the LCD monitor after shooting. It's also better to avoid having the sun directly in the picture.

297 Fill-flash

Using the camera's small built-in fill-flash has its advantages in outdoor portraiture. When shooting into the sun it will add light to the face, so that your subject is not silhouetted against the brighter background. With the sun behind you it will help to reduce contrast levels and remove some of the unsightly shadows caused by direct sunlight. You may need to experiment to get the right effect.

299 Avoiding red eye (1)

In low light, on-camera flash reflects back off the retina to cause red eye. Most cameras now have a red eye reduction setting, which emits a small burst of pre-flash to narrow down the pupil before the main flash.

298 Slow-sync flash

In low light you will usually need to use flash. However, while this lights your subject nicely it renders everything else in the frame black. To avoid this you can use a slow-sync flash, which sets a slower shutter speed that allows more ambient light to record on the DPS. This is particularly useful if the background is relevant to the picture (e.g. marking a sense of place or occasion). With slower shutter speeds camera shake can spoil your picture, so it is best to set the camera on a tripod or support it in some way.

300 Avoiding red eye (2)

While red eye reduction helps, it is rarely foolproof. The best option is to use a flash off-camera, angled in to the subject from about 45 degrees.

301 Avoiding red eye (3)

Failing off-camera flash, you can try getting the subject to look away from the camera, or adding some ambient light—by switching on a room light, for example.

302 Bounced flash

Light straight from a flash unit is like direct sunlight and produces hard shadows and high levels of contrast that accentuate lines and wrinkles. You can soften the lighting by having your subject stand next to a large, bright—preferably white—surface, such as a wall, which you can then bounce the flash light off. This will produce much softer lighting, with less defined shadows that are more flattering on the face.

303 Self portraits

It's easy when you are behind the camera to forget that you're part of the family and to end up with many pictures of the family that exclude you. It may not be possible to find someone else to take the picture, so this is the time to turn to the camera's self-timer. The best technique is to compose the picture first, leaving room at the edge to add yourself after pressing the shutter release.

304 Adjusting the time delay

Most cameras allow you to adjust the self-timer's time delay, so make sure that you have given yourself enough time to get into the picture and settle down. It's always worth checking the LCD screen afterward to make sure you haven't cropped too tightly.

305 Candid portraits

Spontaneous photographs of people are far more natural than posed shots. Keep an eye open for photo opportunities in public places such as markets and parks. You'll need a telephoto lens (ideally about 200mm), or a high magnification zoom (around 5x–10x), so that you don't impose on the subject and spoil the unposed effect. You should, however, seek permission from your subject with this sort of picture.

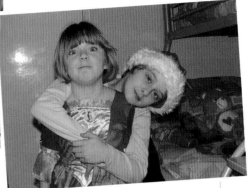

Candid, non-posed portraits make for very natural pictures.

At night and in low light

Photography doesn't have to stop just because the sun's gone down. Night and low light conditions provide some great photo opportunities.

306 Use a tripod

Low light demands slow shutter speeds. To avoid camera shake causing blurred pictures, it's essential to use a tripod in these conditions. Make sure that the tripod is sturdy enough for the weight of the camera and activate the shutter with a remote release or utilize the self-timer (as described on page 64).

307 Shutter speed

To take good pictures in low light you need a camera that has the facility to set long shutter speeds, often in excess of a second. Some have a setting known as the "bulb" setting, which allows you to leave the shutter open indefinitely so long as the shutter release is pressed.

308 Noise

All digital images have an element of noise, caused by stray signals and random pixels. At fast shutter speeds, this noise is usually unnoticeable but at slower shutter speeds it shows up. To reduce the level of noise, set the "noise reduction" (NR) function to "on." The longer image processing and storing time will be worth it.

Long time exposures at night can cause high levels of digital noise.

309 Adjusting ISOE

If the shutter speed indicated by the meter is unacceptably slow, you can increase it by adjusting the ISOE rating to a faster setting:
- your camera gives a shutter speed of 8 seconds at ISOE 200
- altering the ISOE to 1600 makes it react to light eight times more quickly
- you need only 1/8th the amount of light for an acceptable image to form (which, in this example, equates to 1 second).

310 Fast lenses

The greater the maximum aperture of the lens (i.e. a "faster" lens), the more your control over shutter speed settings. In tip 309, switching from a lens with a maximum aperture of f/5.6 to one of f/2.8 would give two extra stops of light, and an even faster shutter speed of a 1/4 second. The faster the lens, the brighter the viewfinder, and the easier it is to use.

311 Handheld light meter

Although the camera will almost certainly have a built-in light meter, you may find it easier to work with a handheld meter. Often, these have greater latitude and can read low light levels that fall outside the range of the camera's own meter.

312 Mirror lock-up

The ability to lock up the mirror on DSLRs is useful, if not essential. It helps prevent image blur caused by vibration, which is exacerbated with long shutter speeds.

313 Moving subjects

The mirror in a DSLR locks up electronically just after you press the shutter but before the shutter curtain opens. This has the advantage that you don't lose vision through the viewfinder, or the AE and AF functions, before you release the shutter, but it does cause a slight delay between pressing the shutter and the picture being taken. It's worth remembering this when photographing a moving subject.

314 Take a Flashlight

To help you to see what you're doing, take a flashlight with you. You'd be surprised how useful it can be and how often you end up using it.

315 Focusing

Focusing in very low light can be a problem, unless the AF works by infrared distance detection. If the AF works by contrast detection, low light may cause it to fail. If so, try to find a bright area close to your main subject, such as a street lamp or a lit window, and use it to focus. Otherwise, if you have the option, use manual focus.

316 Focusing by guesswork

As a last resort, you can use guesswork for focusing. Attempt to gauge the distance between you and the subject and use the focus scale on the lens to set focus. Set a smaller aperture to gain depth-of-field.

317 Know your camera

A problem with night photography is being unable to see clearly all the controls on the camera. It's worth practicing using your camera and setting the main controls blindfold or with your eyes closed, so that out in the field you can operate it without having to refer to markings.

318 Safety

You should take extra care at night, particularly in built-up areas. Photographic equipment can attract the wrong type of admirer. Travel with a friend if you can, be alert, and keep only a minimum of equipment with you.

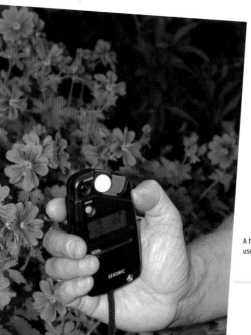

A handheld light meter is useful in low light.

319 Recommended exposure settings

The list below suggests exposure settings for particular subjects at night but you may want to experiment to find what works for you.

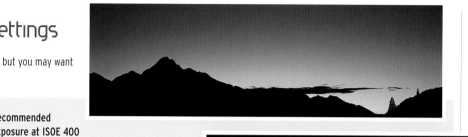

Subject	Recommended exposure at ISOE 400
Floodlit buildings at night–front-on to camera	1/4 sec @ f/4
Floodlit building at night–angled to camera	1 sec @ f/8
Funfairs (to freeze motion)	1/125th @ f/2.8
Funfairs (to blur motion)	1/15th @ f/8
Fireworks	Up to 1 min @ f/8 or f/11
Lightning	Up to several min @ f/8 or f/11
Star motion	4–8 hours @ f/8
Moon (clear night)	1/250th @ f/16
Floodlit sports events (to freeze motion)	1/125th @ f/5.6
Floodlit sports events (to blur motion)	1/30th @ f/11
Light streaks from automobiles (busy road)	10–20 sec @ f/22
Landscapes (under full moon)	4 min @ f/11
Landscapes (under partial moon)	8 min @ f/11
Street scenes (with pavement lights)	1/4 sec @ f/8
Cityscapes (close-up)	2 sec @ f/11
Cityscapes (wide-angle)	8 sec @ f/11

Sport

In sport, the defining moment often happens in an instant. Therefore, getting good sports images means being prepared and keeping vigilant.

320 Backgrounds

Keep your eye open for obtrusive backgrounds.

Keep an eye open for distracting action in the background and try to compose the shot so that the viewer's attention is focused on the main subject. For example, you can use depth-of-field to render only the principal subject sharp or selective exposure to darken and obscure conflicting backgrounds.

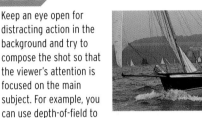

321 Anticipation

Knowledge of the sport will help you to anticipate the action, giving you the chance to have the camera ready in the right place and at the right time. Anticipating the shot will go a long way to making sure that parts of your subject aren't lost out of frame.

You need to anticipate the action for good sports photography.

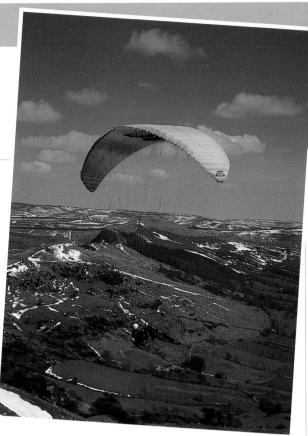

322 Zoom in

Another way to ensure that the background doesn't detract from the subject is to zoom in tight on a particular aspect of the action. You'll need to get as close as possible and use a long telephoto lens (e.g. 300mm) or high-magnification zoom (around 10x).

Use a high magnification zoom or telephoto lens to get close up.

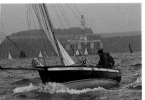

323 Shutter lag

For fast action sports remember to allow for shutter lag–the interval between pressing the shutter and the shutter actually activating, which can be anything up to a 1/4 second. This may be all it takes for the action to have passed and for you to miss the shot.

324 Get in position

Try to get a good vantage point to photograph from, where your view is not obscured by spectators or other obstructions. For example, trying to photograph a baseball game from the stand will generally mean having to shoot through an exuberant crowd when anything exciting happens.

325 Eye-level action

Getting down to pitch level is a better option. Watch the action for a while and see if you can pick up on specific trends (such as the line taken by racing cars, horses in a steeplechase, or cyclists on a mountain climb), and then get yourself in the right position to photograph the action.

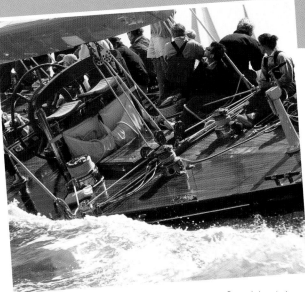

For great atmospheric shots, get down at eye level to your subject.

326 Camera panning

Use the camera panning technique for clear images of fast moving subjects.

To freeze the action in some sports, such as motor racing and speedway, try following the movement of the subject with the camera—a technique known as panning—and press the shutter partway through the movement. Keep panning after taking the shot to avoid a sudden stop causing camera shake and image blur.

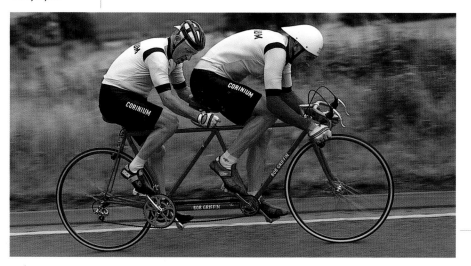

327 Get creative

It's not necessary always to show action in frozen state. Sometimes, you can create a more emotive shot by deliberately blurring the motion of the subject. Set a slow shutter speed, such as 1/10th, and use the panning technique described in tip 326. It may take several attempts to get the right effect, but it's something worth experimenting with.

328 Use your imagination

Don't just think about the sports action itself, but keep an eye open for everything else going on that's peripheral to the event. Some of the best photographs may be candid shots of supporters displaying the emotions that go hand-in-hand with sporting triumph or disaster, or of the location itself.

329 Keep shooting

The best technique in sports photography is simply to keep shooting, since you can delete the pictures that don't work and there's no additional cost involved for extra film and processing.

330 Sport and safety

Some sports, particularly powered sports, can be dangerous for anyone involved, especially photographers who may be trying to get themselves into a prime vantage point for the picture, and therefore in harm's way. Never put yourself at unnecessary risk and always follow the instructions of safety officials.

Vacations and travel

Traveling presents ideal opportunities for photography. Turning holiday snaps into something more than personal mementos, however, can be harder than it looks, unless you know how.

331 Look for the unusual

Keep a lookout for scenes that you wouldn't normally associate with a vacation. Instead of famous monuments, consider a theme that shows a more personal side to the location, such as local people shopping at street markets, chefs cooking at an outdoor restaurant, or even the food itself, which is often colorful and artistically displayed.

332 Candid moments

Be ready for the special fleeting moments that sometimes occur and that often become the talking point of the vacation. Keep your camera to hand, making sure that all the functions and modes are set to their typical settings, ready for action.

Watch out for candid moments when traveling.

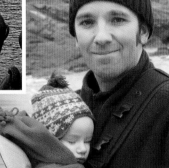

333 Capturing a sense of place

Pictures of yourself and your fellow travelers will be more interesting if you include additional information in them. For example, showing a wide expanse of the surrounding scenery or your mode of transport will give a sense of place, while street banners, or special lights and decorations, will create a sense of occasion.

Don't forget to take a few pictures to show where you were.

334 Aerial shots

When traveling by air, take some pictures from the airplane's window. The best technique is to keep the lens parallel with, and close to, the small window, to avoid reflections and glare. Watch out for an inappropriately placed wing creeping into the corner of your pictures—although this can also help to create a sense of where you are.

Remember to show your mode of travel.

Keep your camera with you when flying.

335 Converging lines

When we think of a journey we think of long distances traveled. This can be very simply portrayed by photographing a scene with converging lines. Roads and railway tracks are perfect examples, and including them will give your vacation photographs a sense of adventure and discovery.

336 Airports

With a digital camera you do not have to worry about X-rays fogging your film but carrying delicate equipment on an airplane can still be stressful. It is best to carry anything of value with you onto the plane. If your camera gear is either too big or too heavy and you have to place it in the hold, then pack it in a suitable bag, such as one of the molded plastic hard cases now available (see page 29).

337 Crowd dodging

To avoid the crowds at scenic spots and tourist locations, get up very early. Most visitors arrive during late morning and stay till the afternoon before heading back to their hotels. Getting up early will reward you with great lighting and crowd-free vistas.

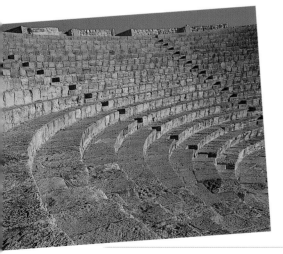

338 Carrying equipment

Once you are at your destination, it's best to carry your equipment in a small backpack, or, for a small camera and a few accessories, in a belt-attaching hip bag, both described on page 29.

339 Security

It is sensible to be aware of the environment and people around you. Tourists wielding expensive digital cameras can fall prey to the less honest factions of society. Keep vigilant and try to stay within a group to avoid the worst.

340 Attitude and ethics

Be respectful of the country and the people you are visiting. You will certainly find many of the cultural differences you encounter worth photographing, but make sure you seek permission first. If you are waved away, accept the wishes of the individual and do not take the picture.

Image Editing

After image capture, the next stage is processing the digital file taken from the camera to make a picture you're totally happy with. What in film-based photography takes place in a darkroom, with the acrid odor of chemicals, can now be done in a well-lit room, using a computer.

THE DIGITAL DARKROOM

At the beginning, we looked at the equipment you need to use in capturing the digital image. This part of the book considers the kit that may be needed for image processing.

Buying a computer

There never seems to be a good time to buy a computer. As soon as you've bought one, a new, improved model becomes available, often at half the price you've just paid for yours. Here are a few hints and tips to keep you ahead of the game.

341 Processor

Most processors in new computers are perfectly capable of operating at the speed that's required for digital photography applications. Specifically, however, you should look at Windows-based PCs with the Pentium series chips, or Apple Macs with a G3 processor or higher.

342 RAM

RAM, or random access memory, is the amount of memory the computer uses to process current applications and actions. The amount of RAM your computer has is a particularly important feature for digital image processing. You should consider 256mb as a minimum and the more you have, the better the computer will perform.

343 Hard disk drive (HDD)

The computer stores data permanently on its hard disk drive (HDD). As digital photographs can be quite big in terms of file size–up to 60 or 70mb, or even more, it doesn't take too many of them to begin filling your HDD. Hard disk space is relatively cheap, so choose a system with a lot of it. Some 30 or 40gb is not uncommon now, for a typical computer.

344 Interfaces

Computer peripherals, such as scanners, graphics tablets, external disk drives, and printers, link to the computer via a cable that plugs into a socket on the computer (an interface). It's worth checking that any computer you might buy has enough of the right type of interface for your needs.

346 Firewire

Another version you might hear of is FireWire (IEEE 1394), which is a high speed standard suitable for work even at professional level.

345 USB Connections

Most systems now operate via a USB (Universal Serial Bus), which enables plug-and-play functionality. There are now two types of USB: 1 and 2. USB 2 is more modern and works at a faster speed.

347 Earlier interface types

Older interface types include SCSI and Serial Bus. These are both outdated for modern peripherals and I wouldn't recommend them for digital photography. A minimum of two FireWire ports and three USB ports is ideal.

348 Desktop computers

Desktop computers tend to be less expensive than laptops, and give more computing power for your money. However, they are big and take up a fair amount of desk space. They are not portable, which means you are limited to working in one particular place.

349 Laptop computers

Modern laptop computers have more than enough processing power for digital photography and the best screen technology is sufficient for professional work. They have the advantage that you can carry them with you wherever you go. However, this portability comes at a premium in terms of price. The decision between a laptop and desktop computer is ultimately a personal choice.

Laptop computers have the advantage of being portable.

350 Apple Mac or PC?

Again, this decision comes down to personal choice. Apple Mac computers are the norm in most graphics. PCs have the advantage that there is far more software written for the PC format, which may persuade you down that route if image processing isn't going to be the sole use of the machine.

Computer monitors Another very important

piece of equipment is the computer monitor. This is what you will use to review all aspects of your photographs, from sharpness to color to exposure. A quality monitor will make the job far easier and will help to ensure that what comes out of the printer is what you expected to see.

351 Screen types

There is more than one type of screen to choose from.

There are two main types of color monitor: the CRT (cathode-ray tube) and the LCD (liquid crystal display). Each has its advantages and disadvantages.

352 CRT or LCD?

CRT screens are less expensive but more bulky. They produce very high quality on-screen images, but suffer from flicker, which can make viewing for long periods of time uncomfortable. LCD screens are more expensive but have the big advantage of taking up less room on your desk and producing a stable, flicker-free image.

353 Screen size

The minimum screen size you need for image processing is 15 inches (38cm), and a 17-inch (43cm) screen is preferable.

354 Software-based calibration

Most systems now come with a software-based calibration facility, such as Adobe Gamma. Such facilities are perfectly fine for general everyday use.

355 Color management

The monitor must be calibrated with your printer, so that the printer reproduces faithfully the colors you see on the screen. Otherwise, you may be making unnecessary color adjustments that will show up when you print the images. You should be able to adjust the brightness and contrast on the monitor, and, ideally, to alter the shape and position of the image on screen and to control convergence.

356 Color and resolution

The screen should be capable of displaying millions of colors (which may require an upgrade to the computer's video card). Screen resolution should be a minimum of 1024 x 768 pixels. Screens for professional use, such as the LaCie 22-inch (56cm) CRT monitor, work at 1800 x 1440 pixels, which is ideal for serious image processing.

357 Hardware-based calibration

For critical color management you may want to invest in one of the hardware-based calibration systems, such as those produced by Optical. These systems have a sensor that measures the color output of your screen, allowing you, with the appropriate software, to adjust the individual color channels separately and with the greatest accuracy.

Useful peripherals As well as the basic computer,

there are various add-ons that you might want to consider. All are useful accessories in the digital darkroom.

358 Storage media

For a number of reasons you might want to consider storing your image files somewhere other than the HDD on your computer. This might be for security reasons or because you need extra storage capacity, for instance. There are several options.

359 External HDD

An external HDD sits externally to your computer and is linked via a USB or FireWire connector. These devices have one major advantage: if you ever decide to change your computer for a newer model, you don't have to retrieve all the images you have stored on the internal HDD. You simply unplug the external drive and plug it into the new computer.

Images can be backed up on an external device for safety.

360 CD writers

The CD is the common form of media used in computing today. How long this will last is another matter. CDs are cheap to buy and quick to use and they offer a good solution for the needs of most digital enthusiasts. One word of caution: make sure any device is ISO 9660 accredited, which means it is compatible with both PCs and Macs.

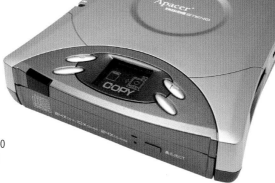

361 DVD writer

The DVD is the most cost effective technology for removable storage and gives much greater capacity than the CD (in the region of 9gb compared with around 700mb). The drawback is the speed at which you can read and, particularly, write data—which is far slower than a CD.

362 Zip disks

Zip disks hold a limited amount of data (up to 250mb), but are small and portable and ideal for low-level general use. The disks themselves are sturdy and reliable, which makes the zip device useful as a temporary backup solution.

363 Card reader

Digital files can be transferred to the computer directly from the camera. However, there are times when you may want to use a card reader. These small and portable devices take the memory card from the camera (some are card-specific, while others have multicard compatibility) and transfer the files to your computer.

364 Graphics tablets

Graphics tablets are an evolutionary step up from the mouse. They have a pen-like stylus and a flat tablet resembling a mouse pad. The stylus allows much greater control over hand-drawn lines, which can be very useful in some aspects of image processing.

365 Jump drives

These ingenious little devices allow you to store and easily carry up to 256mb of data, which can then be transferred back to a computer. They are the ultimate in temporary portable storage and work via a USB port.

Scanners

So far, this book has concentrated on photographs captured by a digital camera. But you can also turn film-based pictures into digital files by scanning them. To do this you will need either a flatbed scanner or a film scanner.

366 Optical quality

Image quality depends somewhat on the quality of the scanner's optical components. Select from manufacturers such as Nikon, Canon, Minolta, Umax, Microtek, Heidelberg.

367 Flatbed scanners

These have great versatility, and can be used to scan transparencies and negatives (using an adaptor), through to prints and pages from books or magazines.

368 Film scanners

Film scanners will only scan film (either transparency or negative). However, like for like, they do produce digital images of better quality.

369 Film adaptors

To scan film on a flatbed scanner you need an adaptor. If you go down the flatbed route, check that the scanner comes with an appropriate adaptor, otherwise you'll end up paying more than you thought.

370 Resolution

For good quality images that can be enlarged to a decent size (say, around 10 x 8 inches/ 25 x 20cm), choose a scanner that has a resolution of at least 2700ppi (points per inch).

371 Maximum density

For scanning color transparencies, if you need high-quality output, choose a model that has a maximum density of 3.6 or more. Scanners with a lower density value will lose detail in shadow and highlight areas.

372 Film carriers

A flimsy film carrier may reduce the quality of your digital scan. Choose a model that has a sturdy film carrier.

373 Film formats

Different scanners will accept different sized film formats. A flatbed scanner will generally accept all formats with the right adaptor. However, some film scanners are suitable for 35mm film only.

374 Dust removal

Some scanners have a facility for digitally removing dust from the scanned file. This can be a very useful time saving function, though you should be aware that it may not be possible to remove all the scratches from a piece of film.

375 Over-sampling

Some scanners use a technique known as oversampling. A built-in device samples an image more than once and averages the results. This helps to remove unwanted data (noise), which is random and therefore stripped out by sampling. The result is better image quality and reduced artifacts.

IMAGE PROCESSING TECHNIQUES

With digital photography, image editing is easily accomplished by computer. What follows are hints and tips for getting the most out of your digital pictures, using some of the most common and easily applied techniques. The examples are given in Photoshop, a typical image-editing software program.

376 Photoshop tool bar

The Photoshop tool bar is something you will need to get to know very well as your digital photography skills develop.

Marquee
Selects and encloses an area of the picture space, indicated by a pattern of moving dash marks that form the boundary. The shape of the selection will depend on the style of Marquee chosen from the options available: Rectangular, Elliptical, or Single row or column.

Crop
Selects and encloses the portion of the picture you want to retain. Can be resized and rotated for accurate selection.

Move
Is used for moving a selected portion of the image, or the whole color layer.

Lasso
Is used to draw around and enclose an area of the image. There are three types of Lasso:
* Freeform, which allows you to draw as if by hand
* Polygonal, which draws point-to-point, making a shape of multisided straight lines
* Magnetic, which follows the edge of an object.

Magic wand
Enables you to select all neighboring pixels of a similar color. You can also add dissimilar pixels.

Airbrush
Sprays diffused strokes of color, much like using an aerosol spray paint in real life. The size, pattern, and hardness of the spray can all be altered.

Paintbrush
Paints colors or effects onto the image, with greater precision than the Airbrush tool allows. Brush size, shape, hardness, and opacity can all be altered.

Pencil
Works in exactly the same way as the Paintbrush tool and can be similarly adjusted, but draws like a pencil.

Eraser
Erases pixels and selected layers or areas of the picture space. Variations include:
* Background eraser, which paints in the background color
* Magic eraser, which changes portions of the image back to the way they appeared when last saved.

Rubber stamp
This tool is mostly used to copy one portion of an image to another (sometimes referred to as "cloning"). It can also be used to paint patterns onto an image.

Blur
Decreases the contrast between neighboring pixels.

Sharpen
Increases the contrast between neighboring pixels.

Smudge
Smears the colors of an image.

Dodge
Allows you to lighten areas of the image.

Burn
Allows you to darken areas of the image.

Sponge
Decreases the level of saturation, making colors appear less vivid.

Pen
The Pen tool allows you to draw a path outline, either point-to-point (Pen tool) or freehand (Free form pen tool). You can then convert this to a selection outline or stroke with color. Options enable you to add a point in the path (Insert point) or delete a point (Remove point). You can also change the point type from, say, a corner point to a smooth arc point using the Convert point tool.

Type
Clicking on the Type tool opens up the Type tool dialog box, which lets you add and format text to your image.

Custom shape

The Custom shape tool allows you to add various predefined shapes to your image, such as stars, new moon, cloud bubbles, and even footprints. As well as funky designs like these, you can also add squares, polygons, and lines.

Gradient

This tool fills a selected area with a gradual transition of color, usually from foreground to background but also customized gradients.

Paint bucket
The Paint bucket tool will fill a selected area with the foreground color or a predefined pattern.

Eyedropper
With the Eyedropper selected, clicking on a point on the image will select the color of that point as the foreground color. Alt/click on a point will set the background color.

Hand
When the image is too large for the viewing window you can use the Hand tool to scroll the viewing window to show different portions of the picture.

Zoom
The Zoom tool will magnify the picture so that individual pixels can be seen more clearly. Magnification will center on the point of the picture selected. Alt/click will reduce magnification.

Slice
The Slice tool is used in Web design for chopping images up into smaller chunks.

Notes
This tool option lets you add a reference note to remind you to do something at a later date.

Getting started
The following tips cover some of the basic information you need for digital picture manipulating.

377 8-bit/16-bit image

High resolution TIFFs can be saved as 16-bit files, which increases the quality of the image. However, many of the functions within Photoshop will only work on an 8-bit file. To convert an image to an 8-bit file go to IMAGE > MODE and select 8-bits / channel.

378 Setting color type

Color monitors use red, green, and blue (RGB), while printers use cyan, magenta, yellow, and black (CMYK). (K = black.) When editing a picture on screen use the RGB color setting, but for reproduction purposes you might want to change it to CMYK. To do this, go to IMAGE > MODE > CMYK COLOR.

379 Undoing

If you don't like the results of your last edit you can undo it using the EDIT > UNDO menu option, so long as you haven't saved the changes. To go back further and reverse previous edits use the EDIT > STEP BACKWARD option.

380 Resizing the image

You can change the size of your image using the IMAGE SIZE option in the IMAGE menu.

Step 1 – Go to IMAGE > IMAGE SIZE.

Step 2 – Enter the new values for pixel size, document size, or resolution. To change the format of the picture, deselect the CONSTRAINT PROPORTIONS box.

Step 3 – Click on OK.

Note : The file size will alter depending on the changes you make. Making the picture bigger or increasing resolution will increase the file size and vice versa.

381 Document size

You can increase the print size of the picture by increasing the size of the document.

382 Resolution

If you want to get photo-quality prints from your pictures, you'll need to select a resolution of at least 300 pixels/inch. For downloading images onto the Internet a resolution of 70 pixels/inch will be sufficient.

383 Pixel size

Increasing pixel size will create a larger digital file, which may be important if you want to sell your digital pictures to a publisher. Most publishers want a file of at least 40mb.

Using LEVELS

384 Using LEVELS (1)

The LEVELS dialog box can be used for quick fixes to make a dull picture appear more vibrant. Images without a full range of tones between black and white are said to look "flat." The LEVELS control can be used to make a flat image appear more vibrant and lively.

Step 1 – Open the LEVELS dialog box IMAGE > ADJUST > LEVELS.

Step 2 – To adjust highlights, drag the White slider (on the right) until it corresponds with the point of the histogram where the value is above zero. As you do, you will see the image brighten.

Step 3 To adjust shadows, drag the Black slider (on the left) until it corresponds with the point of the histogram where the value is above zero. As you do, you will see the image darken.

This process is called "re-mapping." Effectively it sets the darkest area of the picture to black and the brightest part to white, thereby increasing the tonal range.

385 Using LEVELS (2)

Rather than using the sliders to map the variation in tone you can use the Black, White, and Gray Eyedroppers.

Step 1 – Open up the LEVELS dialog box IMAGE > ADJUST > LEVELS.

Step 2 – Click on the Black Eyedropper (on the left). The cursor changes to an Eyedropper symbol.

Step 3 – Click on the area of the image that you want to correspond to pure black. The image darkens.

Step 4 – Next, select the White Eyedropper (on the right) and click on the area of the image that you want to correspond to pure white. The image brightens again, but the overall result is a more vibrant looking picture.

Step 5 – Finally, you need to set the mid-tone point, particularly if you notice an overwhelming color cast. Do this by selecting the Gray Eyedropper (the middle one), and clicking on an area of the image that should be a middle-tone color.

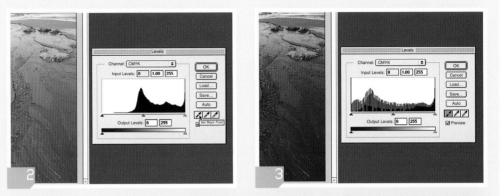

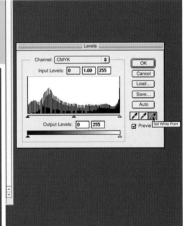

386 Using LEVELS (3)

LEVELS can be used to add or remove contrast. You can alter the level of the mid-tones in the picture without dramatically affecting the highlights and shadows by using the Gray slider (in the middle). This alters the overall contrast of the image.

387 Using LEVELS (4)

When using the Eyedropper tools it is a good idea to enlarge the image to a size where you can select individual pixels easily. This will increase the accuracy of the re-mapping process.

388 Using LEVELS (5)

When using the White Eyedropper avoid selecting reflected highlights, such as the reflections from water, metal, or glass, as they hold no detail and will produce an inaccurate white point.

389 Using LEVELS (6)

If you're not sure about using LEVELS at this stage, then you can opt for the AUTO LEVELS control under the IMAGE > ADJUST menu. The computer will check red, green, and blue channels in the image and optimize each for tonal range.

Using CURVES

390 Adjusting brightness with CURVES

You can also adjust brightness and contrast levels using the CURVES control. CURVES is a very powerful image editing tool that could form an entire chapter of a book by itself. This is a simple introduction.

Step 1 – Go to IMAGE > ADJUST > CURVES.

Step 2 – Select the color channel you want to alter. To begin with, try leaving this at the RGB setting, which will alter all three channels together.

Step 3 – Drag the cursor over the center point of the graph and shift the line up to brighten the picture and down to darken it.

Step 4 – Keep adjusting the settings until the line's slope is sharpest where you want most of the contrast to be–shadows, mid-tones or highlights.

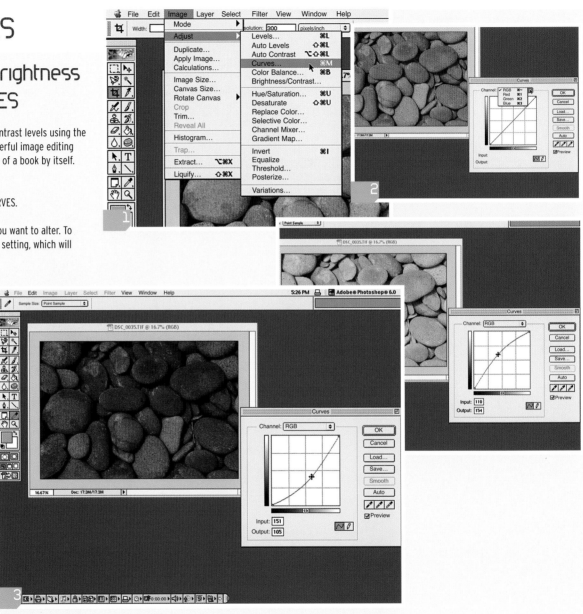

391 Brightness and contrast

You can also adjust the levels of brightness and contrast using the IMAGE > ADJUST > BRIGHTNESS/CONTRAST option from the menu bar. Adjust the sliders until you get an image you're happy with.

392 Auto contrast

The auto contrast feature of Photoshop will optimize the brightness range without affecting the color balance. Try it if you are unsure of using the manually adjustable functions at this stage.

394 Cropping for better composition

You can change the story your picture tells by using the CROP tool to alter the composition. Cropping can also remove distracting background features.

Step 1 - Select the CROP tool.

Step 2 - Left click the mouse and drag the cursor to enclose the area of the picture you want to keep. The area outside the boundary lines will darken.

Step 3 - Adjust the crop to the precise size using the top, bottom, and side points.

Step 4 - Once you're happy with the new composition, action the crop: IMAGE > CROP.

393 Removing dirt and dust

Dirt and dust that accumulate on the photosensor appear as large, dark splodges on your pictures. These can be removed using the Rubber stamp cloning tool.

Step 1 - Enlarge the image (Zoom tool) until you can clearly see the unwanted marks.

Step 2 - Click on the Rubber stamp icon.

Step 3 - Select an appropriate size (large enough to cover the mark, if possible) and style of Cloning tool. For dust marks, use one of the hard-edged options.

Step 4 - Select an area of the image to clone from, adjacent to the dust mark, by pressing the ALT key and Left clicking the mouse simultaneously (this turns the cursor into a rubber stamp).

Step 5 - Position the reference circle over the dust mark and Right click. The dust mark disappears.

395 Changing formats

Pictures can be given a new format using the CROP tool. For example, a picture taken in landscape format can be made into a square or portrait image.

Using the Crop tool you can change the shape of your images.

396 Keep quality in mind

Cropping an image deletes pixels. If you crop too much, you may reduce the quality of the image to below an acceptable level. To avoid this, increase the size of the image (see tip 380) before cropping to make up for the loss of pixels.

397 Rotating an image

If the image you open is in the wrong format (e.g. a portrait shot displayed in the horizontal format), you can rotate it round to its proper setting.

Step 1 – Go to IMAGE > ROTATE CANVAS.

Step 2 – Select an appropriate degree of rotation. For example, to change a horizontal format back to a portrait format select either 90º CCW (counter-clockwise) or 90º CW (clockwise).

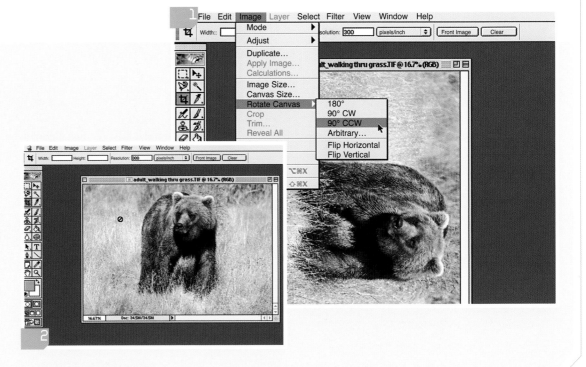

398 Flipping an image

You can flip an image to invert it. This is useful because we are more comfortable when the flow of the composition runs left to right, but–particularly in wildlife photography–it's not always possible to get your subject running in the direction you want.
Use IMAGE > ROTATE CANVAS > FLIP VERTICAL/FLIP HORIZONTAL.

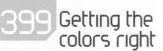

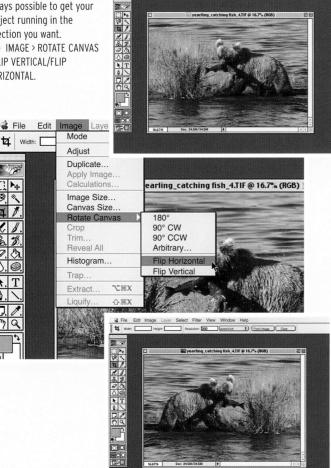

399 Getting the colors right

Digital images are made up of three layers of color: red, green, and blue (RGB). Usually, your camera will process each image so that there is an even balance of all three colors, producing a picture that looks on the screen much as it did at the time you took it. Sometimes, however, one of the colors predominates.

Step 1 – Go to IMAGE > ADJUST > COLOR BALANCE.

Step 2 – Select MIDTONES and use the three sliders to adjust the color to a tone that suits. To adjust the color balance in the highlights and/or shadows, select the appropriate setting.

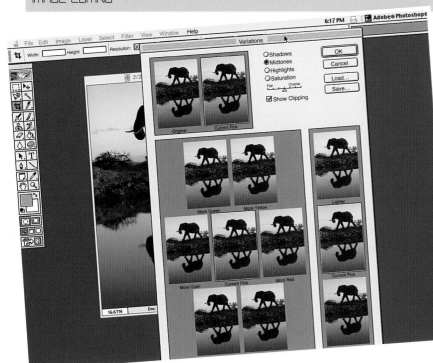

400 Variations

The VARIATIONS control IMAGE > ADJUST > VARIATIONS will show you a preview of seven different images at different settings, including the current setting. This is used in assessing color balance and to preview three separate images at different brightness settings.

401 Color and the monitor

Altering color on the monitor for reproduction purposes is a bit of a black art. How your monitor is calibrated, the type of light you're working under, and even the color of the walls around you will all have an effect on how the image appears on the screen.

403 Reaching saturation point

Digital images straight from the camera often lack the vibrancy of color visible in the original scene. You can easily make slightly dull pictures more colorful by adjusting the level of saturation IMAGE > ADJUST > HUE/SATURATION by around +15% to +20%.

402 Playing with color

Some of the other controls can have an effect on how color appears in your photographs. For example, the colors in a flat scene can be made more vivid by using the BRIGHTNESS/CONTRAST, CURVES, or LEVELS controls.

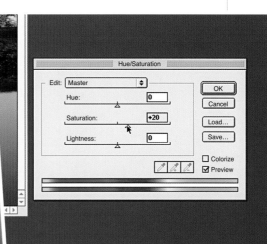

Saving digital images

Saving your files is the final stage of image editing. How you do this will depend on what you plan to do with the images and also on how much free hard disk space you have.

404 Saving to a computer or digital media

Step 1 - In the IMAGE > IMAGE SIZE menu, set the resolution to 300dpi. This will give good quality prints from an ink-jet printer.

Step 2 - Go to FILE > SAVE AS.

Step 3 - Select the destination folder and name the image. Make the name relevant so that it is easily identifiable.

Step 4 - Select a file type. For reproduction and ongoing editing, choose the TIFF option. If you want to save disk space, and have finished editing the picture, then you may prefer the JPEG option.

405 Saving for use on the Web

Step 1 - In the IMAGE > IMAGE SIZE menu, set the resolution to 70dpi. This is the maximum resolution of a computer monitor. It will reduce the file size of the image, which helps when downloading over a modem. (Don't be perturbed when the picture is reduced in size on the screen.)

Step 2 - Go to FILE > SAVE FOR WEB.

Step 3 - In the settings box, choose the JPEG option and set the level of quality required. For most web applications, the MEDIUM or HIGH setting is suitable (giving a quality setting between 30 and 60). To make precise adjustments use the QUALITY measure but keep the file size below 100K.

Step 4 - Click on OK to save the file.

ADVANCED IMAGE PROCESSING

Your images should now be looking full of life and visual energy. But the editing process doesn't have to stop there—following this group of tips will help to make your photographs really stand out from the crowd.

406 Selective exposure control

Sometimes you may want to alter the exposure of just a part of a scene. For example, you may have photographed a landscape where the sky is much brighter than the foreground.

Step 1 - Use the Magic Wand tool to select the area of the image to be adjusted. You will need to spend some time making sure that the selected area perfectly matches the horizon, as a poor selection will be very obvious.

Step 2 - To make life a little easier, it is worth making your edits in the QUICK MASK mode. To do this, press Q on the keyboard to enter QUICK MASK.

Step 3 - Open the LEVELS dialog box and make the necessary adjustments.

Step 4 - To turn QUICK MASK off, press Q again on the keyboard.

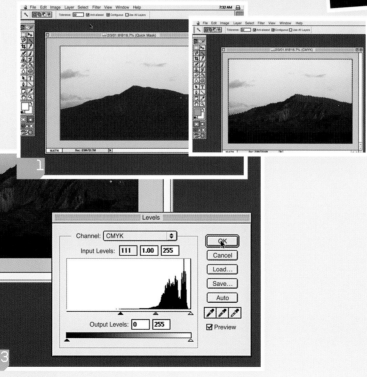

407 Shift-select with Magic Wand

You can add any areas of the picture that the Magic Wand tool missed first time around by holding down the Shift key and Left clicking the mouse with the Magic Wand tool selected.

408 Smoothing rough edges

Getting a smooth transition between the adjusted and non-adjusted areas of the picture can be a little tricky. To smooth over the jagged edges often created by the Magic Wand, with an active selected area, try practicing with some of the settings in the SELECT menu (see tips 409–412).

SELECT Options

409 SELECT > GROW

This will expand the selection to contiguous pixels with similar colors.

410 SELECT > SIMILAR

This will expand the selection to both contiguous and non-contiguous pixels with a similar color.

411 SELECT > MODIFY > SMOOTH

This will help remove the rough edges produced by Magic Wand.

Smooth Selection

Sample Radius: 1 pixels

412 SELECT > MODIFY > EXPAND/CONTRACT

This will help overcome JPEG fringes around the edges of your selection.

Expand Selection

Expand By: 2 pixels

413 Dodging

Another technique for controlling exposure is dodging. This lets you lighten specific areas for precise exposure control (below).

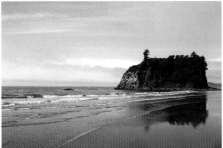

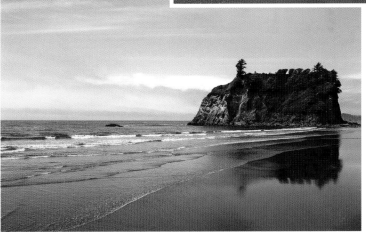

414 Burning

The opposite of dodging is burning, a technique that allows you to darken areas of the picture (inset).

415 Dodging and Burning tool bar

When you select either the Dodge or Burn tools a menu bar will present itself at the top of the screen. It's worth practicing with this to perfect your technique.

416 Sponging

You can saturate or desaturate the colors in a scene using the Sponge tool. Saturate will deepen color and Desaturate will lighten color. The Pressure setting defines the strength of the Sponge tool's effect.

Using the Sponge tool you can saturate or desaturate colors.

417 Removing distracting objects

Sometimes, however well you've composed the picture, distracting objects appear in it. When this occurs, you can use the Clone tool to delete them. The process is much the same as outlined in tip 393, but you need to use a smaller Rubber Stamp tool for more precise cloning.

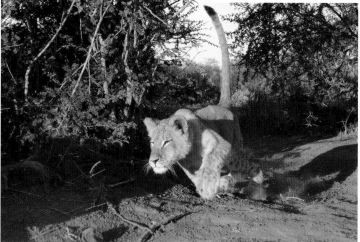

Distracting elements in the image can be removed with the Rubber Stamp tool.

418 Creating panoramic landscapes

Panormaic format often suits landscape images.

Use the Crop tool to create panoramic format landscapes in either horizontal or vertical orientation. This is most effective when the picture is taken with this in mind.

419 Create telephoto images

If your digital zoom lens lacks in image quality, you can create a telephoto effect and produce a better quality photo by using the Crop tool instead. Take the picture with the lens set to its standard position and then use image editing software to crop out the unnecessary background. If the area to be cropped is quite big, then increase the image size of the picture first (see tip 380).

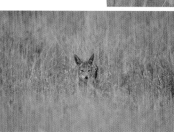

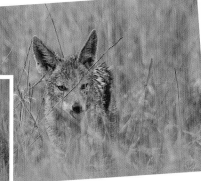

Cropping can be used to create frame-filling, "close-up" images.

420 Straightening sloping horizons

Horizon lines that slope are very disorienting and will ruin an otherwise good picture.

Step 1 – Select the Measure tool and draw a line parallel to the horizon.

Step 2 – Look at the angle shown in the information bar at the top of the screen. This is the degree of slant.

Step 3 – Select IMAGE > ROTATE CANVAS > ARBITRARY.

Step 4 – Enter the angle displayed in the information bar into the dialog box and select either counter clockwise (CCW) or clockwise (CW) rotation. Then click on OK.

Step 5 – Crop the image to remove the blank canvas that is now visible, using the technique described in Tip 394.

Deconverging verticals

One of the problems with tall buildings or monuments is that the more you angle the camera upward, the greater the distortion of the verticals. Shift lenses to overcome this are very expensive. A simpler technique is to use tools in Photoshop.

Step 1 – Select the entire image SELECT > ALL.

Step 2 – Select EDIT > TRANSFORM > DISTORT.

Step 3 – Drag both bottom corners inward until the sides of the building or monument look straight.

STEP 4 – Apply the changes by clicking on the √ box on the menu bar.

STEP 5 – Crop the new image to remove the blank canvas now visible.

Converging lines (right) can be corrected (above).

423 Removing red eye

If you get a photograph of a subject with red eye, all is not lost. Here's a simple technique to solve the problem.

Step 1 – Magnify the image so that the affected eyes are big enough to work on.

Step 2 – Use the LASSO tool to draw around the red area.

422 Using guides

Rather than using your own visual assessment as to whether the adjusted lines are vertical, you can use the guidelines in Photoshop to give an accurate measure. Go to VIEW > NEW GUIDE and click on VERTICAL before entering the position of the guide. To remove the guideline(s) select VIEW > CLEAR GUIDES.

Step 3 – To avoid a slight red fringing, expand the selection using the SELECT > MODIFY > EXPAND command, entering a value of 1 or 2 pixels.

Step 4 – To avoid a hard line around the modified area, feather the edge. Select SELECT > FEATHER and set a value of 1, 2, or 3 pixels.

Step 5 – To remove the red coloring select IMAGE > ADJUST > HUE/SATURATION and, in the dialog box, set the saturation slider to -100. This will turn the selection gray.

Step 6 – To turn the now gray pupil to black without losing the catchlight in the eye, choose IMAGE > ADJUST > LEVELS. Adjust the Black slider to the right until you get the desired result.

424 Sharpening up the edges

If your pictures look a little soft around the edges, you can sharpen things up using the Unsharp Mask filter. While it's impossible for any software to add to information that doesn't exist in the first place (you can't make an out of focus original appear in focus), it is possible to get the most from the information that is present.

Step 1 – Go to FILTER > SHARPEN > UNSHARP MASK

Step 2 – Position the cursor over a portion of the picture where there is a high level of contrast.

Step 3 – You will need to set the values for AMOUNT (%), RADIUS, and THRESHOLD (see tips 425–430).

SHARPENING options

Amount

This controls the strength of the effect. Experiment with settings of between 100 and 200 until you get the right result.

Radius

The radius setting controls the spread of the sharpening effect. The greater the radius, the sharper the result. Watch out for unsightly halos around high contrast edges that will spoil your picture.

Threshold

This setting sets a contrast threshold below which no sharpening takes place, and helps to keep areas of even tone, such as skies, from becoming grainy.

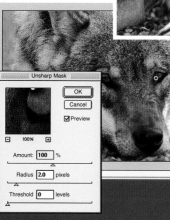

General settings

For most pictures, the following settings will give satisfactory results:
AMOUNT (%) – Between 75 and 150%
RADIUS – 1 or 2 pixels
THRESHOLD – 0 levels.

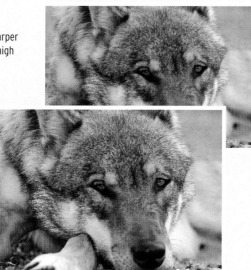

429 Images with fine detail

For pictures where a lot of very fine detail is visible, you can increase the AMOUNT:
AMOUNT (%) – Between 175 and 225%
RADIUS – 2 pixels
THRESHOLD – 0 levels.

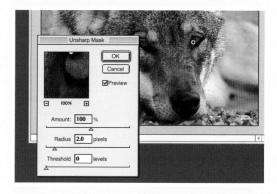

430 Areas of tone

To improve sharpness where there is subject detail, without overstating film grain, digital noise, or other unwanted information, you can try:
AMOUNT (%) – 55%
RADIUS – 22 pixels
THRESHOLD – 11 levels.

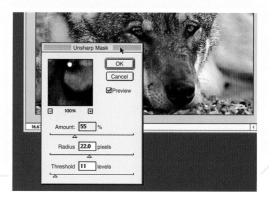

431 Creating blur

Even at a wide-open aperture, depth-of-field can be too great so that the sharp background detail detracts from the main subject. Blurring objects in the background will focus attention on the central point (main image).

Step 1 – Enlarge the image so you can clearly see the objects you will be working on.

Step 2 – Select the Blur tool from the tool bar.

Step 3 – Choose a size and style of brush and set the required pressure at somewhere between 100 (heavy) and 1 (slight).

Step 4 – Apply the Blur tool to the area of the picture you want to de-focus by Left clicking on the mouse.

432 Changing color to black and white

The art of black and white photography is still alive in the digital world. These steps describe the process of creating black and white photographs from color digital files.

Step 1 – Go to IMAGE > MODE > GRAYSCALE. When prompted to discard color information, click OK.

Step 2 – Use the LEVELS control to adjust the level of brightness and contrast.

Step 3 – Black and white images can often benefit from extra sharpening. Use the UNSHARP MASK control to sharpen the edges and increase contrast.

Step 4 – Use the Dodge and Burn tools to lighten (Dodge) or darken (Burn) areas of the picture.

Step 5 – If you want to add a little finishing touch, create a border around the picture, as described in tip 440.

433 Paper to suit

Black and white images are often very well suited to printing on textured art papers, such as watercolor or canvas. It's worth trying a few out to see which you prefer.

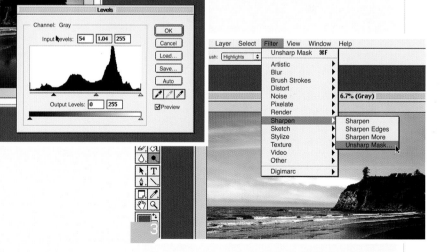

434 Color to sepia

Early photographs were reproduced in a sepia tone. Some pictures look very effective in this style and you can recreate a sepia image in Photoshop.

Step 1 – Go to IMAGE > ADJUST > HUE/SATURATION.

Step 2 – Click on the COLORIZE option. The image will lose much of its color.

Step 3 – Set the HUE value to around 40 and the SATURATION value to around 35.

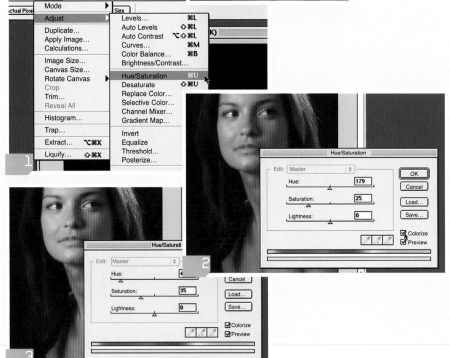

435 Changing the sky

Don't like the existing sky in your photograph? No problem; you can change it.

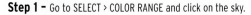

Step 1 – Go to SELECT > COLOR RANGE and click on the sky.

Step 2 – Enlarge the image and tidy up the selection using the Magic Wand tool.

Step 3 – Invert the selection using SELECT > INVERSE. This will make the foreground the selection.

Step 4 – Create a new layer by selecting LAYER > NEW > LAYER VIA CUT.

Step 5 – Open the picture containing the new sky by selecting FILE > OPEN.

Step 6 – Drag the picture from the LAYERS dialog box onto the first image. If the new sky overlays the foreground, bring it to the back by dragging it below the foreground layer in the LAYERS dialog box.

436 Getting the mask right

The key to getting good results with this technique is to get the initial mask as smooth as possible. Your best bet is to zoom in using the Zoom tool and use a small Paintbrush to complete any areas missed by the initial selection tool.

437 Getting the new sky to match

It is very unlikely that the new sky will match perfectly the foreground. You can make small adjustments to the background by selecting the layer in the LAYERS dialog box and using IMAGE > ADJUST.

438 Realistic results

It's equally as important to make sure that the two pictures you use match. For example, a well-lit foreground would look rather odd if matched with a stormy sky.

439 Clouding the subject

Something else you can try with a "flat" looking sky is the TWIRL filter, which will give visual energy to cloud formations.

Step 1 – Make a selection of the area of sky using the Marquee tool.

Step 2 – Go to FILTER > DISTORT > TWIRL.

Step 3 – Select an angle of between 60–90º.

Step 4 – Deselect the selection.

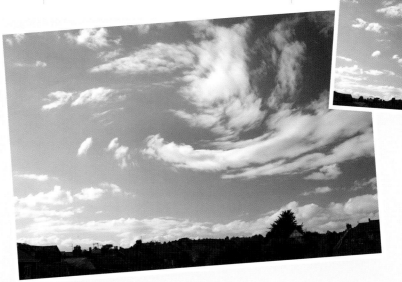

440 Adding borders

Photographs often look better framed with a border. Borders help to emphasize colors and focus attention on the image. A "framed" image will also help your pictures to stand out when posted on a Web site.

Step 1 – Set the background color to the color you want the border to be.

Step 2 – Go to IMAGE > CANVAS SIZE.

Step 3 – Increase the canvas size by the depth you want for the border. For a single border around a 10 x 8 inch (25 x 20 cm) image, plus 1 inch (2.5cm) is a good starting point. To add a 1-inch (2.5-cm) border all around you'll need to increase the height and depth by 2 inches (5 cm).

Step 4 – Set the ANCHOR point to the center square. This will add an even-sized border all around the picture.

441 Multiple borders

You can add more than one border to a picture to increase the impact even more. Just follow the steps outlined above, changing the color of the second border to add contrast between the two.

ADDING ARTISTRY

Image editing isn't always about improving the photographic quality of your pictures. Sometimes you may want to experiment with the more artistic side of the process.

Artistic interpretations

Photoshop allows you to create different artistic interpretations of your photographs. Each style can be accessed from the FILTER menu. Experiment with the various value settings, and review the outcome in the preview box before committing to the change.

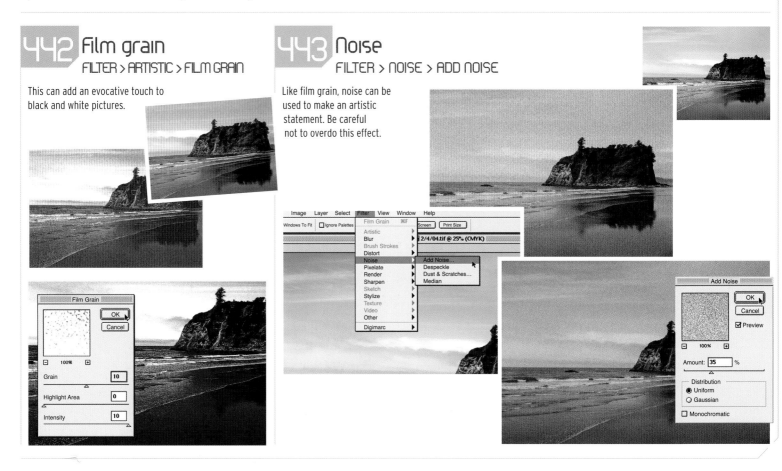

442 Film grain
FILTER > ARTISTIC > FILM GRAIN

This can add an evocative touch to black and white pictures.

443 Noise
FILTER > NOISE > ADD NOISE

Like film grain, noise can be used to make an artistic statement. Be careful not to overdo this effect.

444 Motion blur
FILTER > BLUR > MOTION BLUR

This can give wildlife and sporting pictures a sense of energy. Be sure to use a picture where the subject was moving.

445 Radial blur
FILTER > BLUR > RADIAL BLUR

This one is a little more arty. It needs to be used with care, so as not to look too manufactured.

446 Spherize
FILTER > DISTORT > SPHERIZE

Here's a neat little trick to achieve a fisheye lens effect.

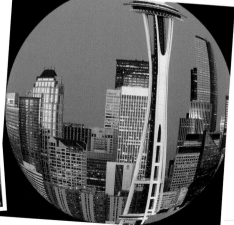

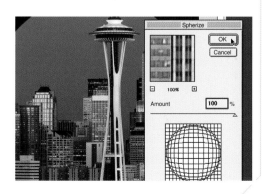

Lighting effects

It's not always possible to achieve the lighting effects you want, either in the field or in the studio. Help is at hand with Photoshop LIGHTING EFFECTS. Some of the more useful options are illustrated here. With each, it's worth playing with the controls to discover all the variations you can achieve.

447 Floodlight
FILTER > RENDER > LIGHTING
EFFECTS > FLOODLIGHT

448 Flashlight
FILTER > RENDER > LIGHTING
EFFECTS > FLASHLIGHT

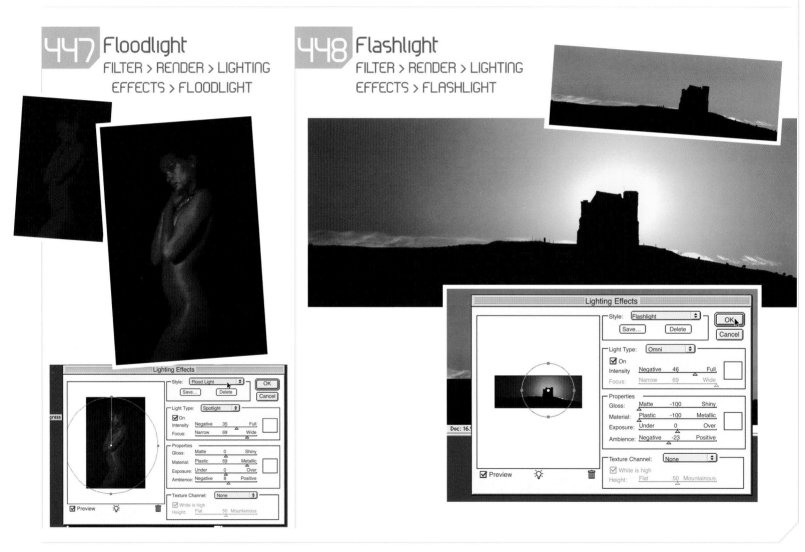

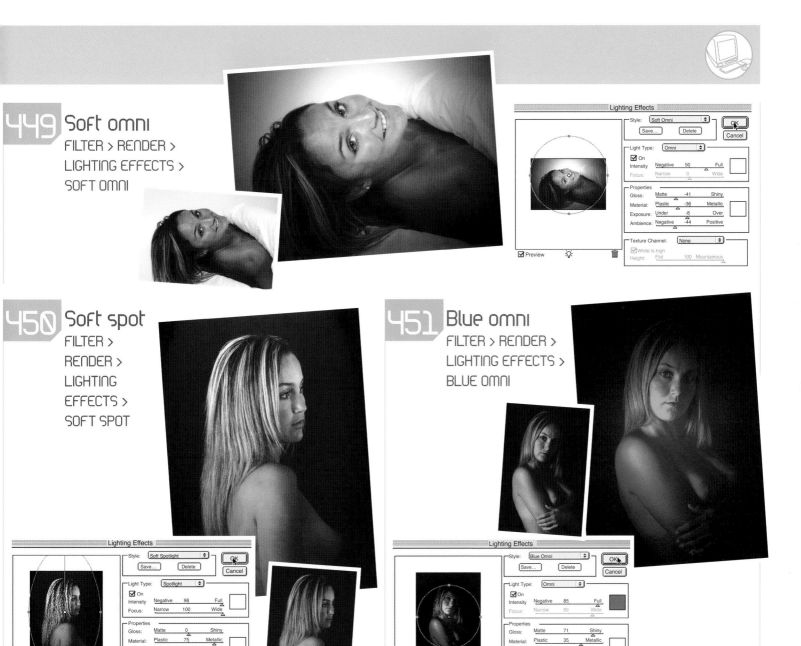

449 Soft omni

FILTER > RENDER >
LIGHTING EFFECTS >
SOFT OMNI

450 Soft spot

FILTER >
RENDER >
LIGHTING
EFFECTS >
SOFT SPOT

451 Blue omni

FILTER > RENDER >
LIGHTING EFFECTS >
BLUE OMNI

452 Adding text

When you create posters, calendars, postcards, or greetings cards you will probably also want to add some text to the picture.

Step 1 – Decide where on your photograph you want the text to appear and what you want the message to say.

Step 2 – Click on the Text tool.

Step 3 – Choose a style (font), size, and color of text from the menu bar at the top of the screen.

Step 4 – Position the cursor over the center of the picture (you can move the text to its exact position later) and type out your chosen message.

Step 5 – Once you're happy with the wording, style, color, and size, click on the Move tool and position the text. You can also use this tool to enlarge or rotate the text.

453 Altering text

Once you have written the text and saved the file you can edit at a later date by clicking on the Text tool and highlighting the text with the cursor.

454 Creative art finishes

Your picture is a photograph, but it doesn't have to stay that way. You can use the FILTER menu to give your images an artistic finish. As with most of these tools, it's worth experimenting. The following are filters that work well with most subjects.

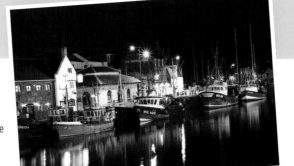

455 Watercolor
FILTER > ARTISTIC >
WATERCOLOR

Watercolor

25%

Brush Detail 14
Shadow Intensity 1
Texture 3

457 Colored pencil
FILTER > ARTISTIC >
COLORED PENCIL

Colored Pencil

11%

Pencil Width 4
Stroke Pressure 8
Paper Brightness 10

456 Rough pastels
FILTER > ARTISTIC >
ROUGH PASTELS

Rough Pastels

16%

Stroke Length 4
Stroke Detail 10
Texture Canvas
Scaling 100 %

458 Mosaic tiles
FILTER > ARTISTIC >
MOSAIC TILES

Mosaic Tiles

100%

Tile Size 15
Grout Width 3
Lighten Grout 9

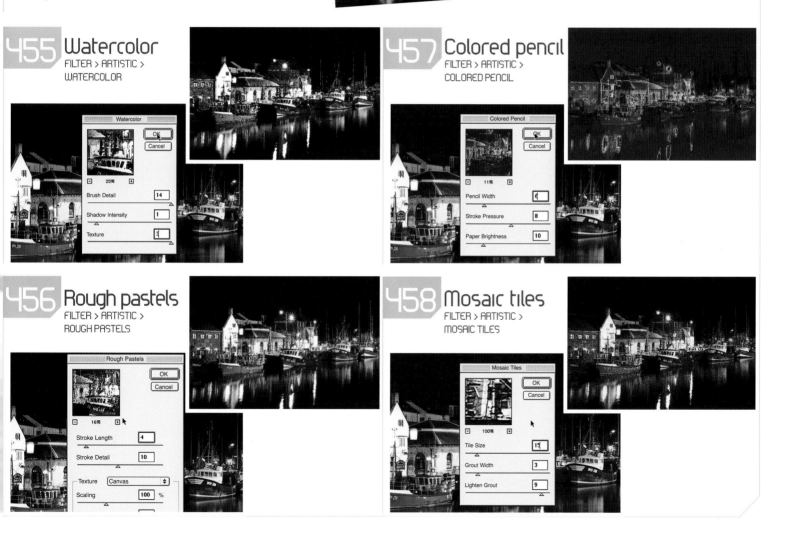

Output

Whatever kind of pictures you take, there is a wide range of options when it comes to using them. And finally, to keep your camera working well, you will need to look after it.

MAKING THE MOST OF YOUR WORK

This part of the book looks briefly at printers and Web sites before going on to suggest some of the many and varied things you can do with your digital photos when you have taken and processed them.

Choosing a printer
There are several types of printer available, to suit a variety of needs and budgets. The four main types are bubble-jet, ink-jet, laser, and dye sublimation printers.

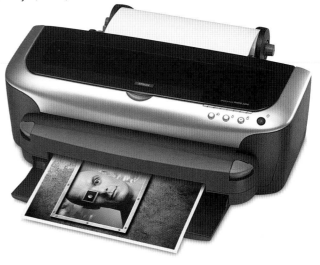

459 Ink-jet printers

Ink-jet printers are the most popular printer type for home use among digital photographers. While they are readily available and very affordable, they also offer many features, and they produce excellent photo-quality results on paper up to small poster size.

460 Laser and dye-sublimation printers

Until recently neither of these would have been considered for home use, being far too expensive. However, prices have come down and more affordable models are now available. The advantage of these printers is the print quality they offer; they produce pictures that are indistinguishable from photographic prints. But options at the lower end of the market are still limited, so unless you are looking to produce work commercially, opt for a good quality ink-jet or bubble-jet printer as best value for money. Otherwise, use the services of a bureau offering professional equipment.

461 Bubble-jet

In essence, the bubble-jet printer works in the same way as an ink-jet printer and provides the same advantages. Look for models made by Canon, Hewlett Packard, and Lexmark for the best quality.

Things to look out for when buying a printer

462 Resolution

In general, the higher the printer resolution, referred to as dpi (dots per inch), the better the quality of the print. However, in practice it's not as simple as that and what the printer does with each dot of ink is just as important a factor in defining image quality. When choosing a printer, it is just as important to review and compare test prints as it is to read the technical manual.

463 Print speed

Some printers can produce a color print in around a minute; others will take over fifteen minutes. This extra time taken isn't always about print quality, either. Sometimes it is down to the different processes involved.

464 Printer ink

Ink-jet printers use one of two types of ink, either dye-based or solid pigment. In general, solid pigment inks will produce images with better color performance and these inks have a greater longevity than the dye inks.

465 Ink cartridges

Some printers keep all the color inks in an integrated cartridge (the black ink is always separate), while others have separate cartridges for each different color. With an integrated cartridge you will have to replace the whole cartridge once any one of the ink colors runs out, whether or not the other ink colors are spent. Here, your choice has little to do with image quality and more to do with economy in use.

466 Six inks or four?

Most ink-jet printers use four ink colors (yellow, magenta, cyan, and black). Newer and—usually—more expensive models also have two extra ink colors: photo-cyan and photo-magenta. Another model has a seventh ink color, gray. All other things being equal, the more ink colors you have, the better the quality of the final output.

Print media (printing paper)

Your paper choice affects the look of the print. For best results, and to minimize printer failure, use paper that is designed to work with your type of printer.

Paper

Computer stores offer a huge variety of printing paper, from fine art to high gloss and from postcard to poster size, panoramic, and preformed greetings cards. Which you buy is largely down to personal choice and it's worth testing paper out on a small scale first. It might be tempting to go for paper made by the same company as your printer, but I have found that non-proprietary brands produce better quality images.

Paper size and quality

The thickness of the paper and its coating will partly determine print quality.
For photo-quality images, use a thicker paper (around 270gsm) with a gloss finish. For more artistic reproductions and special effects, try out some of the art papers available, such as watercolor, hessian, and canvas finishes.

Storing paper

To keep your expensive paper free from dust and image-ruining scratches and fingerprints, never leave the paper in the printer's paper tray for more than short periods of time. When the paper is not in use store it away safely.

Protecting the printer

To make sure that a dusty printer doesn't contaminate your clean paper it's also wise to keep the printer under cover when you are not using it.

Things to do with your pictures

One of the great things about the digital revolution is how much more you can do with your photographs. Apart from making your own prints, you can create greetings cards, calendars, and even your own book. You can also publish your pictures on a Web site or produce DVDs that will play on a TV set.

The World Wide Web (WWW)

Uploading your photographs to the Internet is now a lot easier than it used to be and you no longer need to operate your own Web site to do it. A plethora of online photo galleries have opened up on the WWW, many offering a host of different services. Here are a few names to check out.

471 **PHOTOBOX**
www.photobox.co.uk

472 **FOTKI**
www.fotki.com

473 **SMUGMUG**
www.smugmug.com

474 **PHOTOISLAND**
www.photoisland.com

475 **YAHOO! PHOTOS**
http://photos.yahoo.com

Uploading images to an online gallery

Uploading images to an online photo gallery isn't as complicated as it first seems. Using the FOTKI site as an example, follow these simple steps to share your pictures over the Web.

Step 1 – Open an account (the basic one is free) and click on the CREATE A PHOTO ALBUM link.

Step 2 – Complete the on-screen form and press CREATE ALBUM.

Step 3 – Click on the ADD PHOTOS link.

Step 4 – Click on the ONE PHOTO AT A TIME link.

Step 5 – Use the BROWSE facility to find the photo you want to upload from your HDD or CD drive and then CHOOSE a picture.

Step 6 – Complete the rest of the on-screen form and press UPLOAD.

You're now up and running with your own online photo gallery.

Making prints
Making a print from your digital file is likely to be one of the first and most frequent things you want to do. Making sure that the print you get looks like the picture you created on the computer screen, however, isn't always as easy as it sounds. Here are some tips for making sure that you get what you want.

477 Getting good resolution

Images from most digital cameras will be displayed at 72dpi (dots per inch), which is fine for computer monitors as they share the same resolution. However, the print quality will be very poor, with pixels visible as blocks of color. For good quality prints, set the resolution to 300 pixels/inch using the IMAGE > IMAGE SIZE > RESOLUTION function in Photoshop.

479 Stepping up

If the quality of the photo is poor when printed at larger sizes you can increase the image size using the techniques described in tip 380. To maximize image quality resizing should be done in a single step.

478 Sizing up

While you're in the IMAGE SIZE dialog box, adjust the physical print size to the appropriate dimensions of your output (e.g. 6 x 4in/15 x 10cm for postcard size). If the CONSTRAINT PROPORTIONS box is checked, when you enter the width of the picture the height will be adjusted automatically and vice versa. To set both dimensions manually, deselect the CONSTRAINT PROPORTIONS box. It's always worth checking the image before you print it to make sure it appears as you expect. This will save a lot of money on wasted paper.

480 Direct printing

Several printers will allow you to print photos direct from the memory card without the need for a computer. Fundamentally, these printers will produce adequate results but they lack the powerful image editing capabilities provided for in software packages such as Photoshop.

Producing a contact sheet

You can produce a contact sheet of images in Photoshop. This is a useful way to share a lot of pictures with friends and family without having to print them off individually.

Step 1 – Go to FILE > AUTOMATE > CONTACT SHEET.

Step 2 – Choose your source file from the BROWSE menu.

Step 3 – Next enter the document dimensions and the print resolution.

Step 4 – Enter the number of images to appear on each page (the more images, the smaller they will be printed).

Step 5 – Select the USE FILE NAME AS CAPTION box if you want the file name to be printed under each photograph.

482 Creating a montage

You may want to create a montage as
a souvenir of a recent vacation or to
remember a special event, such as a
birthday or wedding. This can also be
a good way to show off a sequence of
images, such as this yearling brown
bear hunting for salmon.

Step 1 – Go to FILE > NEW to create a
blank Photoshop document. Enter a
document title and set the document size
and resolution.

Step 2 – Set the background color.

Step 3 – Open up each picture you want
to include in the montage, using FILE >
OPEN and drag and drop the picture onto
the blank canvas.

Step 4 – Resize each image
to the desired size and, using
the MOVE tool, position the
images on the canvas.

Step 5 – Add any text you
want, using the Text tool (see
page 108) and save the
document.

Smoked salmon
Katmai National Park - Alaska

483 Designing a postcard

You can create a postcard as a montage, or using a single picture.

484 Producing a poster

How about printing a poster-sized picture to hang on your wall? Here's how to do it.

Step 1 – Choose your picture.

Step 2 – Add a colored surround to frame the picture and help show it off (as described in tip 440).

Step 3 – You could add some text at the bottom.

Step 4 – Print (see tip 440).

485 Novelty gifts

You certainly are not limited to printing your photos out on paper. Nowadays you can have them printed onto a variety of different items, such as mugs, sweatshirts, mouse mats, coasters, and even cakes! A number of Web based organizations offer these services, including PhotoBox (www.photobox.co.uk). Just log onto their Web site and follow the instructions.

486 Make your own TV show

Most digital cameras come with a cable that allows you to link directly to your TV set. Just plug the cable into the camera and connect the other end to the VC in socket on the television set to make a kind of twenty-first century slide show.

487 Creating DVDs

You can also burn your pictures to a VCD or DVD for viewing via a standard DVD player. There are many software packages that will help you to do this professionally, including Roxio Easy CD and DVD Creator and Ulead DVD PictureShow. These programs offer you the option to record to VCD or DVD. Choose the former unless you have a specific DVD burner.

Camera care
Your camera is an expensive bit of kit, full of delicate precision engineering, so it's worth looking after it.

488 Water

All digital cameras are electronic and will not appreciate being dropped in water. Avoid getting the camera wet at all times. If you are out taking photographs in the rain, keep the camera covered with a waterproof material.

490 Filters

You obviously need to take as much care in cleaning any filters you use as in cleaning the lens. Use the same techniques described in Tip 489.

491 Dust and dirt

Dust and dirt have a habit of getting into every little nook and cranny on a camera and finally they can work their way onto the tiny microchips inside. Using an air spray is the best way to keep the camera clean. Every so often, and particularly if you've been on the beach or in a dusty environment, give the camera body a good going over with an air spray, but avoid the front element of the lens.

489 Lens care

You should be particularly careful when cleaning the lens. Use a blower brush to remove any large particles of dust and a special micro-fiber lens cloth to wipe away any surface marks. When using the lens cloth, clean the lens in a circular motion from the center outward.

492 Cleaning the photo-sensor

Photo-sensors in SLR cameras attract dust, which then materializes as specks and blotches on your digital pictures. There is little you can do about this—it's just one of those things, and all camera manufacturers advise that you take the camera to an authorized service center for cleaning. Unfortunately, the cost of this, if you use your camera regularly, soon adds up. I cannot advise you to clean your own photo-sensor—they are very delicate and sensitive bits of technology and it's easy for them to be damaged beyond repair. However, if you decide to give it a go at your own risk, here's what I do to clean mine.

Step 1 - Take a purpose-made swab (I use those made by Photographic Solutions Inc.) and apply just two drops of optical cleaning fluid (supplied by the same company).

Step 2 - Remove the camera lens or body cap and flip the mirror to the up position, following the instructions in your camera's instruction manual.

Step 3 - With the mirror in the up position gently wipe the swab across the sensor, in one motion and in one direction only. Then, turn the swab over and repeat the process in the opposite direction.

Step 4 - Remove the swab and return the mirror back to its normal position. Then replace the camera lens or body cap.

Digital resources

Here are some addresses of Web sites that are sources of useful advice and helpful information on all aspects of digital photography.

493 www.dpreview

A must-visit site for anyone serious about digital photography: news, product reviews, buying guides, readers' forum, and a useful section for learning about aspects of digital photography.

494 www.robgalbraith

Rob is a guru of digital photojournalism, and his site is considered by professional photographers and photojournalists to be the site to visit for the latest news and updates in the digital world.

495 www.shortcourses.com

A really great site for those new to digital photography, providing online books on camera technique and instruction manuals for digital cameras.

 ## www.totaldp.com

News, information, kit guides, and a useful Q&A section make this a helpful and practical site for the digital photography enthusiast.

www.photo.net

Another useful site providing news, reviews, and a great section for learning about photography in general, whether you're a beginner or more advanced enthusiast.

www.natural photographic.com

My own site, which provides links to other sites, as well as to a gallery of wildlife and landscape digital images.

www.wilhelm-research.com

Information about print quality and longevity; test reports on inks and paper for all types of printer.

www.hotwired.lycos.com/webmonkey

Visit this site to learn all about Web site design and build. You'll need a basic understanding of Web technology.

Technical terms

The technical terms, abbreviations, and digital jargon used in the text are summarized below for ready reference.

AE
Automatic exposure.

AF
Auto-focus or automatic focus.

ALE
Aspherical lens element.

Aperture-priority function
Automatic exposure mode, where the user sets the aperture and the camera automatically sets the appropriate shutter speed for correct exposure.

Auto WB
Automatic white balance.

Burning
A processing technique in which specific areas of the image are made lighter, for artistic effect.

Burst rate
The number of images that can be recorded in succession by a digital camera.

Calibration
The process of matching characteristics or behavior of a device to a standard.

Card reader
Portable device for transferring digital files from camera to computer monitor screen.

CCD
Charge-coupled device—a type of photosensor.

CC filter
Color correction filter—these can be used to change the color tone, to make it "warmer" or more blue.

CF card
Compact flask memory card.

CMOS
Complementary metal oxide semiconductor—this is an alternative type of photosensor (see CCD).

Coma
An optical defect that degenerates the image forming ability of a lens at the edge of the image space.

CRT screen
Cathode ray screen (as in the standard type of computer monitor).

CSR
Continuous shooting rate—the number of images that can be taken before the shutter delay locks to enable processing to take place.

Density
The measure of darkness, blackening, or "strength" of an image in terms of its ability to stop light (this is also referred to as its opacity).

Digital grain
See Noise.

Dodging
A technique in which specific areas of the image are made lighter, for artistic effect.

DPS
Digital photosensor—electronic digital photosensors are the digital equivalent of camera film.

DSLR
Digital single lens reflex camera.

Electronic noise
See Noise.

Fill-flash
The camera's built-in flash.

Firewire
A high speed type of computer connection.

FPS
Frames per second—the number of images that can be recorded by a digital camera within a one-second period.

Gb
Gigabytes—a thousand megabytes.

GN
Guide number—the measure of a flash unit's power.

Graphic tablet
An input device that works like a pen on a pad, to be used in image processing.

HDD
The hard disk drive on a computer that serves as a computer's filing cabinet, also known as the hard disk.

Histogram
A graphic representation of tonal range in an image.

Hyperfocal distance
A focus setting used to give maximum depth-of-field.

IF lens
Internal focusing lens—lenses with IF do not extend outward when focusing.

Interface
The way in which a peripheral (such as a scanner) links to the computer.

Interpolate
The way in which the digital camera calculates a color value for each pixel.

IS lens
Image stablization lens.

ISO
International Standards Organization—an industry standard measurement for film and DPS speed.

ISOE
ISO equivalency.

JPEG
Joint photographic experts group—a file format for saving images to memory, which reduces file size.

LCD panel
Liquid crystal display panel—the viewing panel on a digital camera.

LCD screen
Liquid crystal display screen (the superslim type of computer monitor screen).

Macro lens
A lens capable of reproducing a lifesize image.

Mb
Megabytes—units of memory or hard disk space on a computer.

MD
Maximum density.

Memory card
An electronic card that can be inserted into a digital camera to store images in the form of a digital file of binary numbers.

Memory stick
A form of permanent recording device on which to store digital images.

Micro drive card
A type of memory card for digital cameras.

Multimedia card
A type of memory card for digital cameras.

MS
Memory stick—a type of storage device, an alternative to a memory card.

NGD filter
Neutral density graduated filter, a filter that darkens across its surface.

Noise
Electronic disturbances that affect the quality of the photographic image, also known as digital grain.

NR
Noise reduction (see Noise).

Oversampling
A scanning technique that helps to remove noise in the image.

PD
Photodiode—one of millions of light-sensitive cells in an electronic digital photo-sensor (DPS).

Peripheral
An add-on to a computer, such as a scanner, printer, etc.

Pixels
The elements that make up a digital image.

Prism finder
A viewfinder that projects an image, using a system of mirrors.

RAM
Random access memory—a computer's built-in memory.

RAW (raw)
A type of picture file that takes data directly off the digital sensor for storing on the memory device.

SBR
Subject brightness range—the brightness of a subject, compared to the brightness range of the entire scene.

SD card
Secure digital—a type of memory card for digital cameras.

Shutter-priority function
Automatic exposure mode, where the user sets the shutter speed and the camera automatically sets the appropriate aperture for correct exposure—also known as shutter priority auto exposure.

Single lens reflex camera
A type of camera that allows you to see through the camera's lens as you look through the viewfinder.

SM card
Smart media—a type of memory card for digital cameras.

Soft box
A flash attachment that turns a point light source into an omnidirectional light source.

Sponging
A digital technique in which colors in the image are deepened, or lightened, for artistic effect.

Teleconverter
An alternative to a telephoto lens, used to increase the effective focal length of the camera's lens.

TIFF
Tag image file format—a file type for storing images on the memory device.

TTL metering
Through the lens metering—a system of light metering that measures the amount of light reflected through the lens.

USB connection
Universal Series Bus Type connection—a type of computer/peripheral link no longer generally in use.

UV filter
Ultraviolet filter, which filters out ultraviolet light.

VR lens
Vibration reduction lens.

WB
White balance—a camera setting which overcomes color shifts caused by the different color temperatures of light.

Index

Acknowledgements

In writing this book I am, once again, indebted to the
following people: Jane Nicholson at Intro2020,
Paul Harcourt Davies at Hidden Worlds Photography,
Steve Aimes at Bowens International, Jon Anderson at
Calumet, Graham Armitage at Sigma Imaging; and to
Lastolite, all of whom provided images and willing help
when approached.

My thanks also go to Mike Weston for the following
images: tips 333, 335, and 337 (page 71), tips 321 and 326
(pages 68 and 69), and tip 294 (page 63); also to Nigel
Hicks, who supplied the images for tips 285 (page 62),
292 (page 63), 320 (page 68), 325 (page 69), 331 (page 70)
and 340 (page 71).

Finally, to Gary French for additional photography,
Luke Herriott, and the teams that put this book together,
at Rotovision and Natural Photographic, thanks for
making it happen.